29th of March 1734.

Colony of Georgia in America
dedicated by their Honours
Obliged and most Obedient Servant.
...orgie. Peter Gordon.

9. The Lott for the Church.
10. The publick Stores.
11. The Fort.
12. The Parsonage House.
13. The Pallisadoes.
14. The Guard House and Battery of Cannon.
15. Hutchinsons Island.

ANCHORED YESTERDAYS

Anchored Yesterdays
1733 ✠ 1833

By Elfrida DeRenne Barrow
and Laura Palmer Bell

ANCHORED YESTERDAYS

The Log Book of Savannah's Voyage Across a Georgia Century

In Ten Watches

BY ELFRIDA DE RENNE BARROW
AND LAURA PALMER BELL

ILLUSTRATED WITH DECORATIONS BY L. P. B.
TO WHICH ARE ADDED PRINTS OF OLDEN
MAPS BY PETER GORDON AND ISADOR STOUF

THE UNIVERSITY OF GEORGIA PRESS
ATHENS AND LONDON

Published by the University of Georgia Press
Athens, Georgia 30602
© 1923 by Elfrida De Renne Barrow and Laura Palmer Bell
Afterword © 2001 by the University of Georgia Press
All rights reserved

Printed and bound by Thomson-Shore
The paper in this book meets the guidelines for permanence and durability of the
Committee on Production Guidelines for Book Longevity of the
Council on Library Resources.

Printed in the United States of America
05 04 03 02 01 C 5 4 3 2 1

Library of Congress Cataloging-in-Publication Data
Barrow, Elfrida DeRenne.
Anchored yesterdays : the log book of Savannah's voyage across a Georgia century :
in ten watches / by Elfrida De Renne Barrow and Laura Palmer Bell ;
illustrated with decorations by L.P.B. to which are added prints of olden maps
by Peter Gordon and Isador Stouf.
p. cm.
Originally published: Savannah, Ga. : Review Pub. and Print. Co., 1923.

Includes bibliographical references and index.
ISBN 0-8203-2246-6 (alk. paper)
1. Savannah (Ga.)—History. 2. Georgia—History—Colonial period, ca. 1600–1775.
I. Bell, Laura Palmer. II. Title.
F294.S2 B3 2001
975.8'724—dc21
2001027720

British Library of Congress Cataloging-in-Publication Data available

Page three: Cover of the original edition of *Anchored Yesterdays*. Illustration by
Laura Palmer Bell. Front endpaper: *A View of Savannah*, 1734;
back endpaper: *Plan of the City & Harbour of Savannah*, 1818. Both maps courtesy
of Hargrett Rare Book & Manuscript Library/University of Georgia Libraries.

"There are three ways of writing history. The old Victorian way, in the books of our childhood, was picturesque and largely false. The latter and more enlightened habit, adopted by academic authorities, is to think they can go on being false so long as they avoid being picturesque. They think that, so long as a lie is dull, it will sound as if it were true. The third way is to use the picturesque (which is a perfectly natural instinct of man for what is memorable,) but to make it a symbol of truth and not a symbol of falsehood. It is to tell the reader what the picturesque incident really meant, instead of leaving it meaningless or giving it a deceptive meaning. It is giving a true picture instead of a false picture; but there is not the shadow of a reason why a picture should not be picturesque."

G. K. Chesterton, Illustrated London News, June 23, 1923

CONTENTS

Acknowledgements
11

Laying the Keel
13

The First Watch
Hoisting The Blue Peter
1733–1742
17

The Second Watch
Slack Tide
1743–1752
37

The Third Watch
High Seas
1753–1762
47

The Fourth Watch
Troubled Waters
1763–1772
53

The Fifth Watch
Storm Circled
1773–1782
61

The Sixth Watch
To Starboard
1783–1792
75

The Seventh Watch
Grey Horizons
1793–1802
89

The Eighth Watch
White Caps
1803–1812
99

The Ninth Watch
Steaming Ahead
1813–1822
109

The Tenth Watch
The Tricolor,—Ahoy!
1823–1833
121

Afterword: *Anchored Yesterdays* and Its Authors
by William Harris Bragg
133

Authorities Quoted
153

Index
157

ACKNOWLEDGEMENTS

The authors wish to acknowledge their indebtedness to all the former recorders of these historic happenings who have made this small volume possible, while their appreciative thanks are extended to Professor Robert Preston Brooks of the University of Georgia for important and acceptable suggestions; to Mr. Leonard L. Mackall for valuable advice on complicated points, and for bibliographical information; to Miss Anne Wallis Brumby of Athens for her generous assistance in part of the compilation, and to Mr. W. W. De Renne of Savannah for liberal access to the *Wormsloe* Library, and for the privileged use of rare historical material.

LAYING THE KEEL

The desire to relieve the oppressed, the necessity of protecting South Carolina, and the need of a source for the outgrowth of trade, are the principal reasons for founding the Colony of Georgia as stated in a charter granted by King George II of England, June 9th, 1732, which creates its petitioners into an open corporation known as *"The Trustees for Establishing the Colony of Georgia in America."*

The causes leading up to the petition may be explained by a short summary of existing conditions in Great Britain.

With Sir Robert Walpole as Prime Minister, and under his advantageous peace policy England's trade is expanding rapidly, and the American colonies seem a most promising source for the raw materials necessary for her increasing manufactures.

Frontier troubles are causing anxiety to South Carolina, who somewhat weakened by her black slave population is in need of a southern barrier as a defense against anticipated uprisings of the Spaniards and Indians.

In 1729 the attention of Parliament is called to the accumulative abuses of the prison system by James Oglethorpe, who is becoming an outstanding figure of philanthropy in an era of great political corruption. To his military and adventurous spirit, which had early linked his fortunes to those of Prince Eugene of Savoy, is now added a growing interest in the unjustly

oppressed of his own country, and his efforts to help the persecuted Protestants abroad as well as his co-operation with the religious societies in England further demonstrates his humanitarian nature.

Appointed chairman of a committee to investigate the debtors' prisons he is influential in bringing about certain reforms and an act is passed clearing the prisons of many of their inmates.

Doubtless the plan of colonizing discriminately the reputable families from among this victimized class, which numbers into the thousands may be attributed to him, for he becomes a member of a small group consisting of twenty-one men, who instigated by the above reasons, and stating their charitable motives memorialize the Privy Council for a grant of land south of the Savannah River in South Carolina.

In 1729 the Crown had purchased the claims of seven of the eight proprietors of Carolina, to lands ceded to them by King Charles II in 1660. At the time the eighth proprietor, Lord Carteret, had refused to sell his portion (though later relinquishing it to the Trustees). This explains therefore why the grant includes only a seven-eighths interest in *"all those lands, countries, and territories situate, lying and being in that part of South Carolina in America, which lies from the most northern part of a stream or river there, commonly called the Savannah, all along the sea coast to the southward into the Alatamaha, and westerly from the heads of the said rivers respectively, in direct lines to the South Seas."*

The charter is granted for twenty-one years and the Trustees are empowered with the making of laws,

ordinances, and statutes necessary for governing the Colony, while provision is also made for a Common Council, which consisting of fifteen members is vested with greater executive authority.

The generous motives of the Trustees are clearly illustrated in the charter which forbids their either holding office or receiving pay for employment under the Trust, while their attitude towards religion allows *"a liberty of conscience ... in the worship of God"* to all inhabitants of the Province, *"and that all such persons except papists shall have a free exercise of religion."* The recent Jacobite rebellion seems a probable explanation for this exception.

Much faith is placed in the commercial possibilities of the new colony by the Trustees, and their high hopes of a flourishing silk industry are fittingly expressed in the Seal of the Colony which bears a design of the industrious silk worm encircled by the motto: *"Non sibi sed aliis,"*—Not for ourselves, but for others.

In practically the same latitude as the Madeira Islands, Georgia seems favorable for the successful cultivation of wine, while the production of indigo, flax, and potash are all accepted with equal belief of ultimate success.

Consistent with these industrial expectations are the restrictions which are made in connection with the free land grants, two of the most important being the entailment of tenures in tail male and the curtailment in the size of each grant which is limited to fifty acres, while as much as five hundred acres are to be granted to each independent settler bringing with him an adequate number of servants.

Among the most capable and faithful of the seventy-one Trustees who are destined to manage the affairs of the Province for the next twenty years may be mentioned the following: John, Viscount Percival, (later Earl of Egmont) first president of the Trust, Hon. James Vernon, James Oglethorpe, the Rev. Stephen Hales, D. D., the Rev. Samuel Smith, the Earl of Shaftesbury, and Henry L'apostre, Esq.

As a Trustee, Oglethorpe is neither allowed to hold office nor to receive pay for his services, so that in making his decision to accompany the first colonists and see them safely settled he is influenced simply by his spirit of adventure and his benevolent interest. His offer which is entirely voluntary is accepted and approved by the Trustees, who as yet not having appointed a governor, vest him with limited authority of a temporary character.

Five months having elapsed since the granting of the charter the results of the Trustees' activities are shown when the first group of colonists gather at Gravesend ready to start on their adventurous voyage.

Consisting of thirty-five families, among whom are carpenters, bricklayers, mechanics, and farmers as well as the few officials appointed by the Common Council,—three bailiffs, a recorder, two constables, two tithingmen, eight conservators of the peace,—accompanied by the Rev. Henry Herbert, a clergyman of the Church of England, and with Oglethorpe as their leader, they set sail on the "Anne" November 17th, 1732, on their way to *"The Colony of Georgia in America."*

THE FIRST WATCH
Hoisting The Blue Peter
1733--1742

1733

Jan. 13 — The ship "Anne" of 200 tons, John Thomas, Master, anchors off Charleston bar. On board are the first colonists bound for Georgia under the leadership of James Oglethorpe. The following is quoted from "A Brief Account of the Establishment of the Colony of Georgia under General James Oglethorpe": *"Charlestown January 20, On Saturday night 13th January 1733 came to anchor off our bar, a ship with about 120 people, for settling the new colony of Georgia, in which was James Oglethorpe Esqr.; who came ashore that night and was extremely well received by his Excellency, our Governour."*

Jan. 19 — The "Anne" lands at Beaufort Town where Oglethorpe leaves the colonists and accompanied by Colonel William Bull and Jonathan Bryan, proceeds up the Savannah river to Yamacraw Bluff. Here he marks the site of the town, Savannah, and makes a friendly treaty with Tomochichi, the Mico of the Indian tribe of Yamacraws, Mary Musgrove, the half-breed wife of a Carolina trader, acting as interpreter.

Jan. 24 — Oglethorpe returns to Beaufort Town, and the following Sunday is chosen as a day of thanksgiving, being celebrated by a notable feast which, described in the same "Brief Account," consists *"of 4 fat hogs, 8 turkeys, besides fowls, English Beef, and other provisions, a hogshead of punch, a hogshead of beer, and a large quantity of wine; and all was disposed in so reg-*

ular a manner, that no person was drunk, nor any disorder happened."

Jan. 30 Oglethorpe and the colonists embark for Savannah.

Feb. 1 From the same "Brief Account" is quoted the following: *"Being arrived, on the 1st of February, at the intended Town, before night they erected four large tents, sufficient to hold all the people, being one for each tything."*

Feb. 10 Oglethorpe's letter to the Trustees of this date says: ... *"the first House was begun Yesterday in the Afternoon."*

March 12 In Oglethorpe's next letter to the Trustees, written on this day he says: *"Our people still lie in tents, there being only two clapboard houses built and three sawed houses framed. Our crane, our battery cannon and magazine are finished."*

May 14 The "James" arrives in command of Captain Yoakley. The "Gentleman's Magazine" for 1733 has the following: *"This Ship rode in 2 Fathom and a half water close to the Town at low water Mark. The Captain received the Prize appointed by the Trustees for the first Ship that should unload at this Town, where is safe Riding for much larger Vessels."* Among the colonists on board the "James" are a number of Piedmontese who come to give instruction in the silk culture. A book relating to this subject, and dedicated

YESTERDAYS

to the Trustees, which appears about this time, bears the following title: *"A Compendious Account of the whole art of Breeding, Nursing and The right Ordering of the Silk-Worm. Illustrated with Figures engraven on Copper: Whereon is curiously exhibited the whole Management of this profitable Insect."*

The great esteem in which Oglethorpe is held by the Indians and the loyalty and faith of Tomochichi are shown in the treaty signed on this day between the colonists and the Eight Towns of the Creek Nation.

May 21

Over one hundred and fifty settlers are now in Savannah. On this day they assemble at Oglethorpe's tent to name the wards, streets and squares. Lots are assigned, and a Court of Record is established. The first square to be named is Johnson Square, in honor of the governor of South Carolina, and a sun dial is placed in the centre. A trust lot on the same square is chosen as the site for Christ Church.

July 7

This day marks the arrival of forty Israelites who bring with them the Sefar Torah (Book of the Law) and the Echal (The Ark). Their coming is unknown to the Trustees and is contrary to their wishes, though in the general plan to raise money for colonization they had sanctioned the efforts of three English Jews to solicit funds. Instead of turning their subscriptions over to the Trustees they use it for sending their own people to Georgia as settlers. Oglethorpe appreciating their value as citizens allows them to remain. Most of

July 11

them, however, move to Charleston, the Minis, Sheftall and De Lyon families being among those who stay.

Nov. 23
Fatalities having occurred from the *"too free use of rum,"* the Common Council resolves: *"that the drinking of rum in Georgia be absolutely prohibited and that all that shall be brought there be staved."*

1734

March 12
Seventy-eight Salzburgers arrive on the "Purysburg" and are given permission by Oglethorpe to establish a town about twenty miles inland from Savannah which they name Ebenezer (Rock of Help). They abandon this place within two years for a more promising location on the Savannah River. They come accompanied by their religious teachers, the Rev. John Martin Bolzius and Israel Christian Gronau, with Baron Von Reck as their leader. The latter's impressions of the town are quoted in part from his Journal: *"And indeed the Blessing of God seems to have gone along with this Undertaking; for here we see Justice strictly executed, and Luxury and Idleness banished from this happy Place, where the good Order of a Nightly Watch restrains the Disorderly and makes the Inhabitants sleep secure in the midst of a wilderness, I had like to have forgot one of the best Regulations made by the Trustees. I mean the utter Prohibition of the Use of Rum, that flattering but deceitful Liquor, . . . which seldom fails by Sickness or Death to draw its own Punishment."*

| YESTERDAYS | 23 |

 A view of Savannah, made by Peter Gordon, shows that ninety-one houses have now been built, among them the following: a Court House, the Public Store, the Fort, the Parsonage, the Palisades, the Guard House, the Public Mill, the House for Strangers, the Public Oven, as well as the Crane and Bell and the Draw-well. As yet no church building exists, and services are held in Oglethorpe's tent, and later in the Court House. — *March 29*

 Tomochichi, his wife, Scenauki, and his nephew and adopted son, Toonahowi, accompany Oglethorpe to England on the "Aldborough". Oglethorpe takes with him eight pounds of silk as a sample of this industry, which has had little success as yet. It is later exhibited by the Trustees to the Queen, who has it made into a court dress to wear on His Majesty's birthday, while she expresses *"great satisfaction for the beauty and fineness of the silk and the richness of the pattern and at seeing so early a product from the Colony."* — *April 7*

 Tomochichi, his wife and nephew, laden with gifts, return from England where they had been generally entertained, as well as received by royalty. Tomochichi's portrait, painted by William Verelst, and hung in the Trustees' rooms, remains there for many years. — *Dec. 27*

1735

 The Committee on laws and regulations, with Oglethorpe as chairman, recommends the passage of the — *Jan. 9*

following acts: *"An act for Rendring the Colony of Georgia More Defencible by prohibiting the Importation and use of Black Slaves or Negroes into the same." "An Act to prevent the Importation and Use of Rum and Brandies in the Province of Georgia." "An Act for maintaining the Peace with the Indians in the Province of Georgia."*

April 3

The above recommendations are approved by the Privy Council and the three acts in question, slightly amended, become laws.

This year is marked by the arrival of a band of Highlanders accompanied by their pastor, the Rev. John McLeod. They settle New Inverness, later known as Darien. With them come a small group of Moravians, who are given a home situated between Ebenezer and Savannah. Within a few years they move to Pennsylvania because of their religious scruples, which forbids their taking part in the military activities of the Colony.

July 16

The officials of the town receive their first payment in money, which is more in the form of a gratuity than of a fixed salary.

The first school in Georgia, founded for the instruction of the Indians, is established by the Moravians on an island about five miles above Savannah and is named "Irene". Much assistance in the teaching is given by the Rev. Benjamin Ingham.

YESTERDAYS

At a meeting of the Common Council, the Trustees order, *"that Plato's Works, Greek and Latin, and his Republique french be bought for the Use of the Mission in Georgia".*

Free Masonry is introduced with the foundation of Solomon's Lodge, which is chartered this year, and which ranks third among chartered Lodges in the Colonies, priority being given to Massachusetts and Pennsylvania.

Dec. 10

1736

Accompanied by John and Charles Wesley, clergymen of the Church of England, whose missionary spirit had prompted them to accept the Trustees' invitation to fill the pastoral offices at Savannah and Frederica respectively, Oglethorpe returns, and with him come a large number of immigrants whose departure from England is known as the "Great Embarcation."

John Wesley writes his first book of hymns in this year and it is printed by Lewis Timothy in Charleston, (in 1737) under the title of *"A Collection of Psalms and Hymns."* He organizes the first Sunday School in the world, in Christ Church Parish, of which church he becomes third rector.

(This antedates by nearly fifty years the system of Sunday Schools started by Robert Raikes in Gloucester, England.)

The first ball is given in Savannah: *"Several gentlemen from South Carolina, arrived in Georgia, were*

Feb. 5

June 17

entertained by Oglethorpe, and the night before leaving a ball was given them by the ladies."

A lighthouse is being built on the upper end of Tybee Island, *"Constructed of the best pine, strongly timbered, raised upon Cedar Piles, a Brick work round the Bottom."*

Nov. 13

Oglethorpe returns to England to consult the Trustees about obtaining a stronger force to protect the Colony from the alarming encroachments of the Spaniards. As a result of this conference, additional troops are granted by the Crown, and Oglethorpe is made Commander in Chief of His Majesty's Troops in the Carolinas and Georgia.

From Moore's "Voyage to Georgia" written about this time is quoted the following description of the town: *"Savannah is about a mile and a quarter in Circumference, it stands upon a flat of a hill ... (which they in barbarous English call a Bluff) ... the Town of Savannah is built of Wood ... houses are built at a pretty large Distance from one another for fear of fire; the streets are very wide and there are great Squares left at proper Distances for Markets and other Conveniences... there are no lawyers allowed to plead for Hire, nor no Attorneys to take Money but every man pleads his own cause.*

"There is near the Town to the East, a Garden belonging to the Trustees consisting of 10 Acres, ... in the Squares between the Walks were vast quantities

of mulberry trees, this being a Nursery for all the Province, and every Planter that desires it has young trees given him gratis from this Nursery. These white mulberry trees were planted in order to raise silk."

1737

The Colony now numbers over 1000 inhabitants and the following towns besides Savannah have been laid out: Augusta, Ebenezer, New Inverness and Frederica.

John Wesley's Journal reads in part: *"I began learning Spanish in order to converse with my Jewish parishioners; some of whom seem nearer the mind that was in Christ than many of those who call him Lord".*

April 4

A house to house census of Savannah is taken by John Wesley and shows the number of inhabitants to be 518.

July

William Stephens, who had been appointed Secretary to the Trustees in Georgia, arrives in Savannah.

Nov. 1

Unfortunate circumstances force John Wesley to return to England. To quote him: *"I shook off the dust of my feet, and left Georgia, after having preached the Gospel there (not as I ought but as I was able) one year and nearly nine months."* His services as clergyman in Savannah are brought to an abrupt end when he severs his friendship with the Causton family, having been warned of the designing character of Mrs. Causton's niece, Sophia Hopkey, whose charms were

Dec. 2

winning the affections of the *"youthful and susceptible ecclesiastic"*. Due to the scheming efforts of Mr. Causton and Mr. Williamson (Sophia's lately acquired husband) John Wesley is subjected to an undeserved persecution, the outcome of his strict adherence to the ritual of the Church which culminates when he has Mrs. Williamson *"repelled from the Holy Communion"*. Unquestionably his misdirected zeal in certain religious observances had lead to his increasing unpopularity. Many said that *"he drenched them with the physic of an intolerant discipline,"* yet to quote Macauley: *"Whatever his errors may have been he devoted all his powers, in defiance of obloquy and derision, to what he sincerely considered as the highest good of his species."*

1738

May 7

The Rev. George Whitefield and James Habersham arrive with the transport bringing the first detachments of troops. Prior to Whitefield's departure from London the idea of founding an orphanage had been suggested to him by Charles Wesley, who had returned to England in December, 1736, and whose ill health eventually prevents his return.

Aug. 28

The day before his departure from Savannah Whitefield preaches a farewell sermon to *"a Congregation so crouded, that a great many stood without Doors, and under the Windows to hear him"*, so reads William Stephens' Journal of Sunday, August 28, while White-

field's Journal of the same date says: *"This Afternoon I preached my Farewell Sermon, to the great Grief of my dear Parishioners, ... The Weather was exceeding hot, and the Greatness of the Congregation made it still hotter, but God enabled me to preach with Power"*.

In England Whitefield receives from the Trustees a grant of land of five hundred acres for the orphanage which he plans to build near Savannah. Through his eloquence he raises much of the needed funds. Lord Chesterfield says of him: *"He is the greatest orator I ever heard, and I cannot conceive of a greater."*

Sept. 19 — Oglethorpe returns direct to Frederica, bringing additional troops. He reaches Savannah October 10, where he is welcomed with bonfires and public rejoicings.

Oct. 18 — Thomas Causton, Savannah's first bailiff and for many years keeper of the stores, is dismissed from office by Oglethorpe for mismanagement of the Colony's trust funds. Arrogant and tyrannical, Causton is discovered to have perverted the due administration of the law and to have utilized his position for his own advancement. William Stephens, in his Journal, says that Mr. Thomas Jones told him, after investigating Causton's Accounts, *"for his Part he was quite tired looking into such Confusion which he was confident was by Art and Cunning made inextricable."* The woeful condition of the Colony as a result of this betrayal of trust is related in a letter from Oglethorpe to the Trustees in which he says: *"If this (I know not*

what name to give it) had not happened the Colony had overcome all its difficulties and had been in a flourishing condition."

Oct. 19

In all probability, Savannah's first fire is the one to which William Stephens refers in his Journal, when he writes of *"an unhappy Accident of Fire, which in the Forenoon on Thursday burnt down two large Huts, where two French Families lived, viz. Becu, a Baker, and Bailleau, a Hatter."*

Dec. 9

A petition signed by over one hundred freeholders living near Savannah is addressed to the Trustees and in it they ask for the admission of negro slaves into the colony, as well as requesting that the present restrictions relating to land grants be altered to fee simple tenure of lands. They assert that the *"two chief causes of their misfortunes"* are due to the lack of these regulations.

1739

June 6

A returned colonist, reporting to the Common Council says among other items of interest *"That the Free Mason Company having spent all their money is now broke up, and whilst they subsisted, they met every Saturday at the Tavern, & revell'd there 'till 2 a'clock next morning, whence they would reel home."* From a Journal of the Transactions of the Trustees, by John, Earl of Egmont.

June 20

The Trustees' disapproval of the recent petition is shown in their answer to the Magistrates of Savannah.

Their refusal to permit slavery is largely due to the influence of Oglethorpe, in whose opinion *"The idle ones are indeed for Negroes. If the Petition is countenanced the Province is ruined."* The introduction of slaves *"would destroy all Industry among the White Inhabitants"* reads part of the Trustees' answer, tending *"To gratify the greedy and ambitious views of a few Negro Merchants"* and putting it *"into their Power to become sole owners of the Province by introducing their baneful Commodity."* Shortly before, at the anniversary meeting, the Trustees had agreed to certain modifications regarding the restrictions governing land grants. Their refusal therefore to this part of the petition is based entirely on their belief that it originates with idle and undesirable inhabitants.

Anticipating Spanish intrigue, Oglethorpe concludes another treaty with the Indians. — Aug. 21

England's declaration of war with Spain is made known to the townspeople by Oglethorpe. Following the announcement, William Stephens says in his Journal: " . . . *the Militia gave three Handsome Vollies with their small Arms . . ., as it were in Defiance, without the Appearance of any Dread of the Spaniards"* . . . — Oct. 3

Tomochichi dies at the age of ninety-seven, and is buried in Percival Square. The "Gentleman's Magazine" gives the following account: *"He desired his Body might be buried amongst the English in the Town of Savannah, since it was he that had prevailed with the Creek Indians to give the Land, and had assisted* — Oct. 5

in the founding of the Town. . . . the Pall was supported by the General, Colonel Stephens, Colonel Montaigut, Mr. Carteret, Mr. Lemon, and Mr. Maxwell. It was followed by the Indians and Magistrates and People of the Town. There was the Respect paid of firing Minute Guns from the Battery all the time during the Burial, and funeral firing with small Arms by the Militia, who were under arms."

1740

March 25

Whitefield, who returns from England through the northern Colonies, lays with his own hand *"the first brick of the great house which he called Bethesda, i. e., House of Mercy."*

June 11

Although the site of Christ Church had been designated as early as July, 1733, no attempt to build is made until now when a frame structure is begun.

June 26

The first horse race to be held in Georgia is alluded to by William Stephens in his Journal: *"An odd Humour being lately sprung up among some of our People for Horse-Racing. . . . I observed it was promoted by that desperate Crew, whose whole Study and Employment was to disturb the Quiet of the Place and keep the Spirits of the Well-meaning in a continual Flutter. The Race, a little more than a Quarter of a Mile from the Gate of the publick Garden, to the Midst of Johnson's Square."* The *"Bettors"* on this occasion are *"Dr. Tailfer and his Associates."*

"There being now proper Room made at the Orphan-House to receive that Part of the Family that remain'd yet in Town, they all broke up this Day from hence, and went with their Baggage, some in Waggons, some on Horseback, and some on Foot, to settle at Bethesda." From William Stephens' Journal.

Nov. 3

From "A State of the Province of Georgia Attested upon Oath in the Court of Savannah" mention is made of cotton as follows: *"Large Quantities have been raised, and it is much planted: But the Cotton, which in some Parts is Perennial dies here in the Winter."*

Nov. 10

1741

Another mention is made of a fire. In his Journal William Stephens says: *"I was no sooner arrived at the Town's End in the Evening, but I met with the lamentable News of a great Fire that happened about Three a-Clock in the Afternoon, and in a little more than an Hour's Time, burnt down five Houses, in the principal Part of the Town (Part of the first Forty)."*

April 2

The Colony is divided into two counties, Frederica and Savannah, and William Stephens is made president of the latter.

April 15

"During the late Storm we were now informed, the Beacon at Tybee fell flat all at once, which we had expected for some time". From Wiliam Stephens' Journal.

Aug. 15

Towards the close of this year there are sixty-eight orphans at Bethesda. This is the maximum number reached during Georgia's period as a proprietary province.

"*Malcontents*" is the name given to a group of freeholders, chief among them being Dr. Patrick Tailfer, who have long expressed their dissatisfaction over the disappointing growth of the colony. The authors of the following book move to Charlestown where they publish their grievances this year in "*A True & Historical Narrative of the Colony of Georgia in America, by Pat. Tailfer, M. D. Hugh Anderson M. A. Da. Douglas, and others.*" The "*Real Causes of the Ruin & Desolation of the Colony*" are summed up in a series of reasons given at the close of the book, the first being "*The Representing the Climate, Soil, Etc. of Georgia in false and too flattering Colours; at least, the not Contradicting these when publickly printed and dispers'd And Satisfying the World in a true and genuine Description thereof.*"

1742

March

The Trustees incorporate into one law various modifying changes which have been made from time to time in the land grants.

April 30

Claiming that he represents the people of Georgia, Thomas Stephens, (son of William Stephens,) whose behavior (quoting his father) is "*directly oppo-*

site to his Father's Sentiments, and repeated advice," petitions the House of Commons, requesting among other things the adoption of the fee simple tenure of landholding, also urging the need of negro slaves. Believing it best not to interfere with the authority of the Trustees, the House of Commons openly approves of but one request; the importation of rum, and Thomas Stephens is forced to apologize for his antagonistic attitude towards the Trustees. From the record of the meeting of the Common Council held June 29th. is quoted the following: *"Too morrow Stephens is to be brought upon his Marrowbones to be Reprimanded from the Chair."* From "A Journal of the Transactions of the Trustees", by John, Earl of Egmont.

General Oglethorpe, with 632 men, defeats the Spaniards, whose forces number over 5000, at the battle of Bloody Marsh on St. Simon's Island. This remarkable victory saves the English possessions from further invasion and proves Georgia's value as a military colony. It is a deliverance which, in the words of the Rev. George Whitefield, can be *"parallelled but by some instance out of the Old Testament."*

July

"A Journal of the Proceedings in Georgia, beginning October 20, 1737 by William Stephens, Esq; To which is added A State of that Province As attested upon Oath in the Court of Savannah November 10, 1740" is published in three volumes being *"Printed for W. Meadows, at the Angel in Cornhill MDCCXLII."*

Only seventy copies of this valuable record, which covers a period extending through October 28, 1741, are printed by order of the Trustees. This done, they order the *"press to be broke."*

THE SECOND WATCH
Slack Tide
1743--1752

1743

June

The two counties are joined under one government and William Stephens becomes president of Georgia.

July 23

Oglethorpe leaves Georgia for the last time, sailing for England on the "Success".

When not engaged on his official duties throughout the province, he has spent most of his time at his farm on St. Simon's Island, his only home in Georgia and which reverts to the Colony on his departure. When in Savannah he stayed at the house of the widow Overend, No. 1 Jekyll Tything.

While the initial progress of the Colony has been due to his unusual tact in dealing with the Indians, as well as to his military ability which has been invaluable, and where his entire association with the province has been marked by motives of philanthropy, his official connection with civil affairs has not been wholly successful. Partially handicapped by the irregular authority vested in him by the Trustees; his attitude towards matters relating to civil problems and his neglect of duties in this connection have helped to retard the economic development of Georgia.

1744

Francis Harris and James Habersham found the first commercial house in Georgia under the name of "Harris and Habersham". They encourage the plant-

ers by creating a market for their lumber, poultry, deer, hogs, skins, etc.

1746

In writing about Christ Church, President Stephens says: *"The roof of the Church is covered with shingles, but as to the sides and ends of it, it remains a skeleton."*

1747

Dec. 14

The Rev. Thomas Bosomworth, who had married Mary Matthews, formerly Mary Musgrove, becomes a menace to the Colony. Making an alliance with the Creek Indians, he incites Malatche, their king, against the Colony and asserts his wife's claims to the whole territory of the Creeks, while she assumes the title of Independent Empress of the Creek Nation.

1748

July 20

Headed by Bosomworth *"in his canonical robes, with his queen by his side"*, the Creek Indians, following a general convocation, march upon Savananh, striking terror to its inhabitants.

Through the superior discernment of President Stephens, and Noble Jones in command of the militia, a matter which might have proved of perilous consequence is averted. The Indians are made to realize that they have been duped by the designing Bosom-

YESTERDAYS

worths, and they leave the town after smoking the pipe of peace, while Thomas Bosomworth *"returned to rational reflection"* solicits the pardon of the council. Mary Bosomworth's claims are later adjusted when the Trustees pay her a sum of money and confirm to her and her husband full right to St. Catherine's Island, where they had already settled.

1749

This year marks the beginning of commerce in Savannah, and the first effort is made to establish foreign trade, when Harris and Habersham consign a £2000 cargo of lumber, skins, hogs, etc. to a London firm.

A petition is forwarded to the Trustees, signed by the President and a number of inhabitants, again urging that negro slaves be admitted into the Colony. The Trustees yield to this repeated request, which seems justified by existing conditions, and which now receives the endorsement of such men as Whitefield, Habersham, and Bolzius. Restrictions are made, however, governing the treatment of negro slaves, and the Resolutions order *"that the owners should educate the young and use every possible means of making religious impressions upon the mind of the aged, and that all acts of inhumanity should be punished by the civil authority."*

Jan. 10

The use of rum in Georgia, which had been approved by the House of Commons in 1742, continues to be a source of serious trouble to the Trustees, when

their many efforts to have the law prohibiting rum repealed by the King prove unsuccessful, due to the objections of the Board of Trade.

The Savannah Grand Juries fail to indict violators of the rum law, while the Trustees encourage future violations by ignoring its offenders, as well as by making no further efforts to solve this problem by effective legislation.

In the opinion of President Stephens, less rum was consumed in the Colony after its use was permitted, than when it was obtained and drunk clandestinely. In a letter to the Trustees he says: *"A beverage compounded of one part rum, three parts of water, and a little brown sugar was very fit to be taken at meals."*

1750

March 19

At a meeting of the Common Council, it is *"Resolved That the Tenures of all Grants of Land Whatsoever, already made to any Persons within the Province of Georgia, be enlarg'd and extended to an absolute Inheritance; And that all future Grants of Land shall be of an Absolute Inheritance to the Grantees, their Heirs and Assigns.*

Ordered that Instructions be sent to the President and Assistants that they may give the proper Notice to all the People in the Province." This finally gives to the colonists the chief demands relating to land grants, for which they had been striving since the founding of the Colony.

YESTERDAYS

April — Organized for the purpose of caring for orphans and widows, the St. George's Society (later to become the Union Society) is founded. The original members are five in number and represent five distinct religious creeds. Only three names have been preserved: Benjamin Sheftall, Israelite; Richard Milledge, Episcopalian; and Peter Tondee, Catholic.

June 26 — At a meeting of the Common Council, the following appointment is read: *"an Appointment for holding an Assembly of the People of Georgia at Savannah, between Michaelmas and Lady Day next, to propose, debate, and represent to the Trustees what shall appear to them to be for benefit, not only to each particular Settlement, but of the Province in General."*

July 7 — Christ Church is formally dedicated.

Aug. 8 — Quarantine restrictions are shown in the act permitting the importation of negro slaves which includes the following regulation: *"Owing to the number of infected ships bringing the Negroes or Blacks with contagious Distempers, (particularly the Yellow Fever), be it further enacted that a Lazaretto be forthwith built . . . on the West Side of Tybee Island . . . where whole Crews of such infected Ships and the Negroes brought therein may be conveniently lodged and assisted with Medicines . . ."*

1751

Jan. 15 — The first Provincial Assembly of Georgia, composed of sixteen delegates, with Francis Harris as Speaker, meets in Savannah and is *"proportioned to the population of the different parishes or districts."*

March — The first public Filature in America is built in Savannah, an evidence of the Trustees' continued faith in the ultimate success of the silk culture.

April — Henry Parker becomes second president of Georgia, and William Stephens retires to Beaulieu, his plantation near Savannah.

June 13 — The first general muster is held under the command of Captain Noble Jones, *"they behave well and make a pretty appearance."*

1752

A large number of New England Puritans, after living in Dorchester, South Carolina, for over fifty years, come to Georgia and settle Midway, having been granted over 30,000 acres of land.

June 23 — Lack of success in the achievement of their aims and growing difficulties in obtaining financial help from the Government cause the Trustees to resign their charter a year before its expiration, and Georgia is placed under the special charge of the Lords Commissioners for Trade and Plantations.

YESTERDAYS

Sept. 2

This month holds the unique record of containing but nineteen days, owing to the British readjustment of the calendar, from the Julian to Gregorian system of reckoning, when eleven days are inserted between Wednesday 2nd and the following day which becomes Thursday, the 14th. Dates reckoned before this are distinguished by the letters O. S. (Old Style), while those changed to meet the new reckoning are known by the letters N. S. (New Style). The O. S. year began March 25th.

THE THIRD WATCH
High Seas
1753--1762

William Stephens dies at Beaulieu.

1753
August

Georgia becomes a royal province, and the design for the new seal, submitted by the Lords Commissioners of Trade and Plantations is approved by the King. The silk culture is again incorporated in the official seal which is of silver and represents the Genius of the Colony offering skeins of silk to his Majesty with the motto: *"Hinc laudem sperate Coloni."*

1754
June 21

The King appoints Captain John Reynolds governor of the Province.

Aug. 6

Governor Reynolds arrives in Savannah and is received with every *"demonstration of respect and joy"*.

Oct. 29

The first General Assembly of Georgia meets, consisting of eighteen members. The General Courts of the Province of Georgia are established, and Noble Jones and Jonathan Bryan are appointed justices.

1755
Jan.

Having been made to forfeit their possessions and being driven away from their native land, four hundred Acadians arrive on a transport from Nova Scotia. As

1756
Jan.

"*Papists*" the law forbids their remaining. They are, however, taken care of during the winter at the town's expense, and in time all of them take their departure, many of them hoping to work their way back to their "*beloved Acadie.*"

Jan. 16 A public lot is granted by the King for the erection of a Presbyterian Church. The Rev. John J. Zubly becomes its first pastor.

August Because of his arbitrary administration, Governor Reynolds is recalled and Henry Ellis succeeds him as Lieut. Governor.

1757

Nov. 3 French intrigues against the colonists are forestalled when a treaty is signed between the Province of Georgia and the Creek Indians.

Written records of the Masonic Lodge in Savannah are kept as early as this year. The following is quoted from their minutes: *11th. ... That every Person admitted a Bro'r shall decently cloath every ... present with a white Apron, and a pair of white Gloves and shall also give a pair of white Gloves to every Bro'rs Wife, and shall likewise give the Lodge a decent Collation*". From Georgia Documents in the Congressional Library.

1758

March 17 By act of the Legislature the districts of the province are divided into eight parishes: Christ Church,

St. Matthew's, St. George's, St. Paul's, St. Philip's, St. John's, St. Andrew's, and St. James'. The act further provides *"that Bartholomew Zouberbuhler clerk and minister of Savannah shall be the rector and incumbent of Christ Church."* During his rectorship, the first organ ever brought to Georgia is presented to the church by Col. Barnard.

During this year the Filature, containing over 7000 pounds of cocoons, besides a quantity of raw silk, is destroyed by fire.

1759

A Lutheran Church is established in Savannah.

Owing to ill health, Governor Ellis requests his recall, which is granted. Suffering from the summer heat he had complained that the inhabitants of Savannah probably breathed *"a hotter air than any other people on the face of the earth."* A happy coincidence seems responsible for his later appointment as governor of Nova Scotia.

Nov.

The first wharf is built in this year, which greatly encourages commerce, and facilitates shipping.

1760

"His Honour, James Wright, Esq." successor to Governor Ellis, and commissioned Lieut. Governor and Commander in Chief of the Province by the King, arrives in Savannah.

Oct.

1761

March 24

Upon the news of the death of George II, (Oct. 1760) a new assembly convenes and renders funeral honors to his late Majesty, while George III is hailed as king with much pomp and ceremony. *"Thus for the first and only time was a king proclaimed upon Georgia soil."*

Oct.

In his *"Answers to the Queries sent by the Lords of Trade"* Governor Wright says in part: *"The number of white inhabitants according to the return I made in April last, were, men, Women and Children about 6,000 since which the whites have encreased about 700, and the Blacks were then about 3600, and may now be reckoned at least 4500.*

"The Inhabitants are greatly encreased within these ten years, for in the year of 53, there was not more than 2381 whites and only 1060 Blacks, This encrease is owing to the great alteration in the constitution and Government of the Province, tenure of holding lands, admission of slaves, etc. The plan at first proposed by the Honorable the Trustees was not properly adapted for settling an American Colony."

1762

Sept. 7

The earliest manuscript date of a Jewish congregation is the following notice of a deed of gift of a parcel of land by Mr. Sheftall, *"to all persons professing to be Jews"* to be used by them either as a burying ground or as a site for a synagogue.

THE FOURTH WATCH
Troubled Waters
1763--1772

1763

April 7

The first issue of the Georgia Gazette makes its appearance, being published as a weekly by Mr. James Johnson. It is the eighth newspaper to be printed in the colonies. The first item is quoted: *"European Intelligence, Moscow, Nov. 15—The Empress keeps her apartments, not through illness but precaution. The Count Woronzow has given a grand entertainment to the Earl of Buckinghamshire, to which all the foreign Ministers were invited."*

Oct. 7

The four following parishes are added to the Colony: St. David's, St. Patrick's, St. Thomas', St. Mary's.

1764

The Post Office is established with Robert Bolton as postmaster.

This year marks the first shipment of cotton grown in the colonies, when eight bags are shipped by James Habersham to William Rathbone, an American merchant in Liverpool. It is held by custom house officials on the ground that so much cotton could not have been grown in the colonies, and is therefore liable to seizure under the shipping act, as not having been imported in a vessel belonging to the country in which it had been produced.

During the year more than 15,000 pounds of co-

coons are delivered at the Filature, over half being sent by the Salzburgers from Ebenezer.

May 31

Prevalence of smallpox in Savannah causes Governor Wright to give his assent to *"An Act to prevent the further spreading of the Smallpox in Savannah, and in other Parts of the Province"* in which the custom of inoculation is prohibited. The Act appears in full in the Georgia Gazette of this date.

Aug. 16

That the smallpox epidemic is still in progress is seen in *"A Proclamation"* issued by the Governor, and appearing in the Georgia Gazette, which gives permission for smallpox inoculation. The Act recently adopted is shown to *"have not wholly answered the humane and salutary intention of the legislature."*

Dec. 6

The Georgia Gazette has the following: *"Friday the 30th instant being St. Andrew's Day the tutelar saint of Scotland, several gentlemen met at Machenry's tavern, when they established a club by the name of The St. Andrew's Club at Savannah in Georgia, into which upwards of 30 were admitted members."*

1765

Feb. 25

The ship "Friendship" sails for London, having on board 420 barrels and 21 half barrels of rice, 113 hogsheads and 950 bundles of deer skins, 12,498½ lbs. of indico, 710 lbs. of beeswax, and 3000 staves, the whole cargo computed to be of value of about £18,000 sterling.

The news of the Stamp Act reaches Savannah and is received with indignation by the patriots. Over the colonies' protest it had been passed in Parliament during the absence of William Pitt, who, on hearing of their general resistance, says to the King: *" . . . this kingdom has no right to lay a tax on the colonies . . . Sir, I rejoice that America has resisted. Three millions of people so dead to all feelings of liberty as voluntarily to submit to be slaves would have been fit instruments to make slaves of the rest."*	*March 23*
The "Speedwell" arrives with the stamps which are transferred to Fort Halifax for safe keeping. Being informed that the Fort is to be attacked by the "Liberty Boys" and the stamps destroyed, Governor Wright has them removed to Fort George on Cockspur Island, and later for greater safety they are returned to the "Speedwell".	*Dec. 5*

<center>⚏</center>

	1766
The production of silk, never very successful, reaches its height in this year. Despite the encouragement of Parliament, this industry declines, and is finally abandoned in the next few years, while the Filature is repaired and used for an assembly room.	
The Stamp Act is repealed, and to William Pitt, Earl of Chatham, England's foremost statesman, is sent this message: *"To you grateful America attributes that she is reinstated in her former liberties."*	*Feb. 22*

	The Quartering Act which is still enforced causes continued discontent.
Nov. *19*	The population of the Colony is mentioned in a letter from Governor Wright to the Earl of Shelbourne, when he writes: ... *"the white people amount to 9,900 or say 10,000 of which 1800 are effective militia,"* of the number of negroes he ends with the following: .. *"and now, My Lord we have at least 7800."*
1768	
Apr. *11*	Benjamin Franklin is appointed agent *"to represent, solicit, and transact the affairs of the Colony of Georgia in Great Britain".*
1769	
Sept. *19*	Following a meeting of the merchants, resolutions are unanimously passed wherein they agree to import no article that can be manufactured or produced at home.
1770	
Feb. *22*	Governor Wright dissolves the Assembly upon the indignant refusal of the House to negative the election of Noble Wimberly Jones, one of the most ardent advocates of liberty, as Speaker.
Sept. *30*	George Whitefield dies in Newburyport, Mass. The news of his death causes universal sorrow in Savannah. *"All the black cloth in the stores was bought up. The*

YESTERDAYS

pulpit and desks of the church, the benches, the organ-loft, the pews of the Governor, were covered with black," writes a contemporary.

Whitefield's will reads in part: *"I leave that building commonly called the Orphan House, at Bethesda ... to that elect Lady, that Mother in Israel, that Mirror of true and undefiled religion, the Right Honorable Selina, Countess of Huntingdon, ... but if her Ladyship should be called to enter into her glorious rest before my decease to my dear fellow-traveller and faithful, invariable friend, the Honourable James Habersham President of His Majesty's Honourable Council."*

This year also marks the destruction of Bethesda by lightning.

1771

During the year the following ecclesiastic returns of the town are sent to England by the Rev. Samuel Frink, rector of Christ Church:

Church of England	1,185
Lutherans	193
Presbyterians and Inds.	499
Jews	49
Negroes	40
Infidels	30

Governor Wright, having applied for a leave of absence, sails for England. During his absence James Habersham assumes executive duties.

July 10

1772

April

The eighth General Assembly is dissolved by the acting governor, in obedience to royal command, when the Assembly persists, in the face of gubernatorial remonstrance, in electing Noble Wimberly Jones its Speaker. *"This act of dissolution is regarded as an unjustifiable interference with legislative privilege. . . . Its effect is perplexing and deleterious."*

Oct. 7

Benjamin Franklin, the Colony's agent in England, reports as follows in a letter to Noble Jones: *"In my last I acquainted you with the change in Ministry in the American Department, as then expected. It has since taken place. And from the Character of Lord Dartmouth we may hope there will be no more of those arbitrary proceedings in America that disgraced the late Administration. . . . Enclosed I send you a small quantity of Upland Rice from Cochin China. It grows on dry ground, not requiring to be overflowed like the common rice, I send also a few seeds of the Chinese Tallow Tree, . . . T'is a most useful Plant."*

THE FIFTH WATCH
Storm Circled
1773--1782

ANCHORED YESTERDAYS

1773

Feb.

Governor Wright returns from England.

This year, which is made memorable by the "Boston Tea Party" on December 16th, shows the comparative population of Georgia and her neighboring colonies to be as follows:

Virginia	400,000
North Carolina	230,000
South Carolina	140,000
Georgia	33,000

1774

Jan. 26

The Georgia Gazette states that *"Two thousand chests of the East India Company's Tea, that were on board three vessels from London, have been stove and the Tea thrown overboard in the Harbour of Boston, by a number of people unknown."*

June 8

The "Boston Port Bill" is announced in the Georgia Gazette, which, quoting from the London Gazette of April 5th, reads in part: *"the Act of Parliament, passed in the present Session and which takes place on the first of June next to discontinue the landing and discharging of goods, wares and merchandise at the Town, and within the Harbour of Boston."* This news further arouses the indignation of the patriots in Savannah.

June

Legal punishments of the period are shown in the following sentences quoted from the Georgia Gazette: *"At the adjournment of the June Sessions one found guilty of Manslaughter was burnt in the hand with the letter M in Court".* While another guilty of a lesser crime is sentenced *"to stand in the Pillory one hour on Tuesday, "*

July 20

"The alarming and arbitrary impositions of the late acts of the British Parliament" cause the following notice to apear in the Georgia Gazette: *"It is therefore requested that all persons within the limits of this Province do attend at the Liberty Pole, at Tondee's Tavern in Savannah, on Wednesday, the 27th instant, in order that the said matters may be taken under consideration."* Signed by Noble W. Jones, Archibald Bulloch, John Houstoun, and George Walton.

July 27

The patriots meet and adjourn until Wednesday the 10th. of August, resolving to take no further action until representatives have time to arrive from distant parishes.

Aug. 10

Governor Wright receiving information of the above mentioned proceedings, issues a Proclamation in which he calls all such meetings *"unconstitutional, illegal, and punishable by law, and requires all his Majesty's liege Subjects to pay due regard to this my Proclamation as they will answer to the Contrary at their Peril."*

Undaunted, the inhabitants of the Province hold

the adjourned meeting, and adopt unanimous resolutions wherein they proclaim *"That his Majesty's Subjects in America owe the same Allegiance and are entitled to the same Rights, Privileges, and Immunities with their Fellow-Subjects in Great-Britain."* *"That a Central Committee shall have the full power to correspond with the Committees of the several Provinces upon the Continent."*

Sept. 5

The First Continental Congress which is held in Philadelphia is represented by all the colonies except Georgia. Her early stand may be explained by the fact that over half of her people, many of whom were original settlers, are still loyal to the Crown. The youngest of the colonies, she has least cause to take arms against England. She is being governed wisely and impartially, and is prospering under the able administration of Governor Wright. Other colonies have charters on which to base their claims for redress, while Georgia has none.

1775

Jan. 18

A Provincial Congress convenes at Savannah. Although only five out of the twelve parishes are represented, Noble Wimberly Jones, John Houstoun and Archibald Bulloch, are appointed delegates to the Continental Congress to be held in Philadelphia in May. They decline to serve as they do not represent the will of the majority of the parishes.

March 21	The patriotic parish of St. John's elects Dr. Lyman Hall as its independent representative to the Continental Congress. He is unanimously admitted to a seat in Congress *"as a delegate from the Parish of St. John's in the Colony of Georgia."* As a gift from his constituents to the suffering republicans of Boston, he takes with him 160 barrels of rice and £50 sterling.
May 11	The cause of the patriots is strengthened, and Savannah is aroused by the news of the battle of Lexington which had taken place April 19th. The urgent call from the colonies for ammunition results in an attack upon the magazine by Noble Wimberly Jones, Edward Telfair, Joseph Habersham, William Gibbons, Joseph Clay, John Milledge, and others, who seize about 600 pounds of the *"King's Powder"*. (Tradition has it that part of this powder was used at the battle of Bunker Hill, fought on June 17th.)
June	The Council of Safety is organized, with William Ewen as President.
June 7	From the Georgia Gazette is quoted the following: *"On Monday last a considerable number of the Inhabitants met, and having erected a Liberty Pole afterwards dined at Tondee's Long-Room. They spent the day with the utmost harmony, and concluded the evening with great decorum"*.
July 4	The second Provincial Congress is held in Savannah with every parish represented. This is Georgia's first secession convention, and places her in active sympathy with the other colonies. The delegates elected to the

YESTERDAYS

Continental Congress are: John Houstoun, Archibald Bulloch, the Rev. John J. Zubly, Noble W. Jones and Lyman Hall.

During this session the first English armed vessel is captured off Savannah by a Georgia schooner, aided by South Carolinians. This is said to be the first provincial vessel commissioned for naval warfare in the Revolution. Georgia's share of the prize is 9,000 pounds of gunpowder, 5,000 of which is sent to Philadelphia at the request of the Continental Congress.

The port of Savannah is closed to British vessels. *August*

All courts are taken over by the Council of Safety. *Dec.*

On the eve of the War of Independence, *"The royal cause experienced a heavy blow in the demises of Clement Martin, Noble Jones,—associate justice and treasurer of the Colony,—and the Honorable James Habersham, who quickly followed each other to the tomb."*

1776

Governor Wright's position has now become precarious. *"There is hardly a shadow of government remaining,"* he truthfully exclaims, while he assumes a more personal tone in a letter addressed to the Earl of Dartmouth, dated Sept. 23, 1775: *"It is really a wretched state to be left in, not the least means of protection, support, or even personal safety, and these almost daily occurrences are* TOO MUCH, *My Lord."*

Jan.

Jan. 7

This month marks the Governor's arrest by Joseph Habersham, who exacts promises from him to remain a prisoner in his own house, and not to communicate with the soldiers and officers on the ships within the harbor.

A battalion of Georgia troops is organized, consisting of eight companies with Lachlan McIntosh as colonel.

Feb. 7

The Georgia Gazette reads as follows: *"On Friday last our provincial congress proceeded to the election of delegates to represent this province at the Grand Continental Congress, when, on closing the poll it appeared that Archibald Bulloch, John Houstoun, Lyman Hall, Button Gwinnett and George Walton Esqrs. were duly elected, and declared delegates accordingly."* Only three are able to attend, Hall, Gwinnett, and Walton, and these become signers of the Declaration of Independence.

Feb.

The Governor breaks his parole and escapes, making his way to the armed ship "Scarborough."

March 2

The first encounter between the Liberty Boys and the King's Troops occurs when an attempt is made by the British vessels off Tybee to capture eleven rice laden ships lying at the Savannah wharves. Knowing that the orders of the Continental Congress prohibiting the exportation of rice becomes inoperative on this date, the Council of Safety resolves that no ship laden with rice shall be permitted to leave the province and

that all shipping and property, including the homes of the patriots shall be burnt and destroyed, rather than let them fall into the hands of the enemy. The British ships are fired upon as they come up to the town, but during the night they succeed in capturing the merchantmen. Receiving reinforcements from South Carolina, the patriots throw up breastworks on Yamacraw Bluff and fire upon the British. Under orders from the Council of Safety they succeed in burning three ships, dismantling six, while two get away.

April

The Provincial Congress adopts a provisional constitution, and Archibald Bulloch, the presiding officer, is named President and Commander-in-Chief of Georgia. He becomes the first Republican head of the state.

Aug. 10

The news of the Declaration of Independence reaches Savannah. A copy, accompanied by a letter from John Hancock, is sent direct to President Bulloch, who reads it aloud on four different occasions. First, to the Provincial Council, next to the citizens assembled in the public square, then at the Liberty Pole, and lastly in the Trustees' Garden. The celebrations include a dinner under the cedar trees where a toast is drunk to the *"prosperity and perpetuity of the United, Free, and Independent States of America"*, while in the evening a funeral procession marches to the front of the Court House where his Majesty George III is interred in effigy. The burial service reads in part: *"For as much as George III of Great Britain hath*

most flagrantly trampled upon the constitution of our country; we therefore commit his political existence to the ground—corruption to corruption,—tyranny to the grave—and oppression to 'eternal infamy. . ."

Sept. 9

The *"United States"* is officially recognized as the name of this country when Congress orders its substitution for *"United Colonies"* heretofore in use.

1777

Feb. 5

Georgia adopts her first constitution as a sovereign state. One of its provisions converts the twelve parishes of Georgia into eight counties: Wilkes, Richmond, Burke, Effingham, Chatham, Glynn, Camden and Liberty. Seven of these counties are named in honor of distinguished Englishmen, whose sympathies were with the colonies in the events leading up to the Revolution, while the eighth, which comprised the parishes of St. John's, St. James', and St. Andrews', was given the name of Liberty to perpetuate the patriotism of its inhabitants.

The death of President Bulloch occurs during this month and Button Gwinnett succeeds him in office.

May 8

The first General Assembly of Georgia, as a state, convenes and elects Noble Wimberly Jones, Speaker, and Samuel Stirk, Secretary. John Adam Treutlen is made Governor, defeating the opposing candidate, But-

YESTERDAYS

ton Gwinnett. This election results in a personal quarrel between Button Gwinnett and Lachlan McIntosh. The former challenges McIntosh to a duel.

May 16

The duel takes place, fought at a distance of twelve feet. Both men are wounded and Button Gwinnett dies from his injuries a few days later.

June 14

The Continental Congress adopts a national flag, and the *"Stars and Stripes"* becomes the official standard of the United States, replacing the "Grand Union" or "Cambridge Flag" of a somewhat similar pattern. The basic design of this emblem, which originates with a committee composed of General George Washington, Robert Morris and Colonel Ross aided by Mrs. Elizabeth Ross, is the combination of various devices suggested by the Colonial and Continental "colors" of earlier days.

1778

John Houstoun is elected Governor of Georgia.

Jan. 10

British activities in the South begin the latter part of this year. Joint attacks upon Georgia are planned by General Augustine Provost, commanding the British troops in Florida, and Colonel Archibald Campbell, who, with his forces, sails from New York, escorted by a squadron of armed ships commanded by Commodore Parker.

Lieut. Colonel Mark Prevost enters Georgia, and though his troops meet resistance at Midway Meeting

Nov. 19

House, where General Screven is killed, they force the Georgians to retreat. This general attack from the South, however, fails in its purpose owing to lack of proper co-operation between the land and sea forces.

Dec. 27

The British armed squadron and transports anchor at the mouth of the Savannah River, with Colonel Campbell in command of the troops.

Dec. 29

Owing to the complete lack of military ability displayed by General Robert Howe, in command of the Southern Department of the Continental forces, Savannah is taken by the British under Colonel Campbell with over 2,000 troops. General Howe leaves strategic points undefended, especially a secret way of which he had been warned by George Walton and which is discovered by Colonel Campbell through the information given by an old negro named Qaumino Dolly. The Americans, numbering but 672 men, surprised in this overwhelming attack from the rear are forced to retreat. British rule is re-established in Georgia with Lieut. Colonel Prevost in charge.

1779

July 14

Governor Wright returns to Savannah and shortly afterwards resumes his executive duties.

Sept. 3

The French fleet, sent to assist the Americans, appears off Tybee with Count d'Estaing in command.

Sept. 16

The siege of Savannah begins, General Benjamin Lincoln, successor to General Howe, commanding the

YESTERDAYS

Continental troops. His advance guard, led by General McIntosh and Count Pulaski, a Polish nobleman, joins the forces of Count d'Estaing.

A concerted attack takes place, but the British, who are strongly fortified, successfully resist the assault and the Americans are repulsed. Count d'Estaing gives the order to raise the siege and General Lincoln is forced to retreat. The success of the British is largely due to the granting of an ill-advised truce of twenty-four hours, obtained at the onset of the siege and used by them for further strengthening their position, together with the treachery of a Charleston Grenadier, who discloses to General Prevost the plan of attack. Many are the acts of heroism which mark this engagement, none greater than those of Sergeant Jasper and Count Pulaski. The former, mortally wounded, rescues the colors of the Second South Carolina Regiment from the triumphant enemy. Pulaski suffers the same fate, when at the head of two hundred cavalrymen he tries to force a passage through the enemy's line. His death occurs on board the brig "Wasp" and he is buried at sea, while his memory is later honored by elaborate funeral services held in Charleston.

Oct. 9

1781

Early in this year General Nathaniel Greene succeeds General Lincoln as Commander of the Southern Department of the Continental troops.

June

The capture of Augusta by General Pickens and Lieut. Colonel Lee opens the way for a movement upon Savannah. In a letter to Colonel Balfour, dated Savannah, June 11, Governor Wright says: *"If this Province is not recovered from the Rebels without the least delay, I conceive it may be too late to prevent the whole from being laid waste and totally destroyed, ... we are now in a most wretched situation."*

1782

Jan.

General Anthony Wayne comes to Georgia and assumes command. He gradually forces the British southwards. Fort after fort is taken until the enemy concentrates in Savannah; the town is surrounded, and a siege begins.

July 11

Although Cornwallis had formally surrendered his whole army Oct. 19th, 1781, it is not until this date that the British evacuate Savannah, as a result of an order sent by Sir Guy Carlton to Governor Wright, and dated New York, May 23rd. General Wayne and his troops enter the town and take possession, the keys being delivered to Colonel James Jackson *"in consideration of his severe and fatiguing service in the advance."*

THE SIXTH WATCH
To Starboard
1783--1792

ANCHORED YESTERDAYS

1783

Having been subsidized by the British during their occupation of Savannah, The Georgia Gazette had been issued as The Royal Georgia azette, though still under the editorship of Mr. James Johnson, and its first number had appeared Jan. 21, 1779. On this day it makes its reappearance as The Gazette of the State of Georgia. Two items of interest are quoted:

Jan. 30

"The House of Assembly, Tuesday, Jan 7, 1783.

The House proceeded to ballot for Governor for the present year, when after casting up the ballots, Lyman Hall Esquire was elected."

The other item reads: *"On Sunday January 12 the Honourable Major General Greene with his Lady and Suite arrived from South Carolina."*

The following is quoted from the Gazette of the State of Georgia Extraordinary: *"A sloop which arrived on Saturday evening from the Danish Island of St. Thomas in the West Indies brought the St. Christopher Gazette Extraordinary Jan. 23, 1783, from which the following is extracted—From His Majesty's most gracious speech in both houses of Parliament. . . 'Since the last cession I lost no time in giving the necessary orders to prohibit the further prosecution of offensive war upon the continent of North America. I have pointed all my views and measures to an entire and cordial reconciliation with those colonies . . . In thus admitting their separation from the Crown of*

March 17

these kingdoms I have sacrificed every consideration of my own to the wishes and opinions of my people . . . "

Sept. 27

The following advertisement appears in the Georgia Gazette: *" By Permission . . . At the Filature on Thursday, the ninth of October next, will be performed for the benefit of the poor, by a set of gentlemen, the tragedy called 'The Fair Penitent', to which will be added an entertainment, 'Miss in her Teens', or the 'Medley of Lovers'. The doors to be opened at half past five o'clock, and the play to begin precisely at seven no gentleman will be admitted behind the Scenes on any pretence."*

1784

Jan.

John Houstoun is elected Governor of Georgia.

March 3

A Gala Day is celebrated in honor of the ratification of the treaty of peace between the United States and England signed in Paris September 3, 1783. The Georgia Gazette of March 4th says in part: *" the Militia of Savannah and its vicinity were paraded, . . . after being reviewed by His Honor the Governor, were marched to the East Green, where a barbecue being prepared for the Militia they spent the day with that mirth and festivity which so joyous an event naturally inspired."* The assembled multitude dined at the Savannah Tavern. Many toasts were drunk, and for the quaintness of their expression several are quoted:

" . . . Our Magnanimous illustrious friend Louis XVI.

"... The friends of Virtue and Freedom through out the Globe.

"... Uninterrupted Commerce and a truly respectable American Navy.

"... Each toast was accompanied with a discharge of cannon."

1785

Samuel Elbert is elected Governor of Georgia. *Jan.*

The Charter of the University of Georgia is granted, with Abraham Baldwin as one of its founders and its first president. The land for the University is the gift of John Milledge of Savannah. *Jan.*

General Oglethorpe, born in London December 22, 1696, dies at the age of eighty-eight at Cranham Hall, Essex, England. A glimpse into his later life is shown in the words of Hannah More: "*... his literature is great, his knowledge of the world extensive, and his faculties as bright as ever, ... It is the famous General Oglethorpe, perhaps the most remarkable man of his time.*" *July 1*

[The date of Oglethorpe's birth is often given incorrectly. The correct date, as above, was first given by J. L. Chester in NOTES AND QUERIES, July 27, 1867, from the Parish Register of St. Martin-in-the-Fields. See also facsimile in Georgia Historical Society Collections. Vol. VII. Pt. II. 1911. That Oglethorpe, however, celebrated his birthday December 21st is

shown by contemporary evidence. William Stephens in his Journal of Dec. 21, 1737, says: *"This being* MR OGLETHORPE'S *Birth-Day (which is celebrated here annually . .)"*, and again on Dec. 21st, 1739: *"This being his Excellency's Birth-Day, was observed by firing some Guns, and his Health was drank under the Flag, without any Profuseness of Powder or Wine, which he forbid upon any publick Solemnity."*]

General Nathaniel Greene takes up his residence in Georgia during the autumn, having been given Mulberry Grove, the confiscated estate of a Royalist.

1786

Jan. — Edward Telfair is elected Governor of Georgia.

The seat of government is moved to Augusta during this year.

Aug. — Congress (preliminary to the Coinage Act) changes the unit of currency from *"pounds, shillings and pence"* to *"dollars, dimes and cents."*

May 1 — The Chatham Artillery, the oldest company of its kind in the state, is organized with Edwin Lloyd, a Revolutionary soldier, as its first captain.

June 19 — General Greene dies from sunstroke.

June 20 — The remains of General Greene are brought to town for burial.

YESTERDAYS

The following is taken from the Georgia Gazette: *"... every class of citizen suspending their ordinary occupation, united in giving testimonies of deepest sorrow. The several military corps of the town, and a great part of the Militia of Chatham County attended the funeral, ... thirteen discharges from the Artillery and three from the musketry closed the scene."*

The funeral service is read by the Hon. William Stephens, [grandson of William Stephens, Secretary to the Trustees,] there being no minister in Savannah at the time.

In this year Post Stages are running three times a week between Savannah and Charleston, the journey between the two towns taking twenty-seven hours.

1787

The town of Savannah is divided into seven wards, and William Stephens is elected its first president.

Feb.

That a pilot boat is subjected to unforeseen perils is illustrated in the following startling news item from the Georgia Gazette: *"On Tuesday, .. a whale, supposed 60 feet long, came across the hawse of the ship Charlotte, ... coming into the river, passed several times under the ship's bottom and gave her sundry heavy strokes with its tail. ... it afterwards swam to Captain Higgins pilot boat, and after repeated strokes sunk her, ..."*

March 1

May	Georgia sends delegates to Philadelphia to the Constitutional Convention.
1788	
Jan. 2	Georgia is the fourth state to ratify the Federal Constitution when she adopts it unanimously at the convention held in Augusta. This year marks the death of both Samuel Elbert and Jonathan Bryan.
Jan. 20	On this day is organized in this country the first body of Christians wholly of the negro race. The church originates at Brampton's Barn, three miles from Savannah. Andrew Bryan, a negro, is ordained by Abraham Marshall, a white Baptist minister.
Feb. 1	The Chatham Academy is incorporated, being endowed from the proceeds of the confiscated property of British Loyalists. Samuel Stirke is elected President of Savannah.
June 24	Bethesda is rebuilt and opened as a college.
Dec. 23	The following act, having been passed at the session of the Legislature in Augusta *"that the said town of Savannah be known and called by the style and name of the City of Savannah"*, is approved on this day by Governor Telfair.

1789

Georgia's second Constitution is adopted. The Governor's Council is dropped and the Senate is added to the Legislature. It again provides for habeas corpus, trial by jury, freedom of the press and religious tolerance, articles adopted by the Constitution of 1777.

March 12 — From the Georgia Gazette: *"On Friday the 6th inst. departed this life, Mr. Philip Minis, merchant, aged 55 years. He was the first white male born in this state. His remains were interred in the Jew's burial place on Sunday morning, attended by a large number of respectable citizens, who, by their solemn attention, evinced how sensibly they felt the loss the community had sustained in so valuable a member ..."*

May 28 — The news of George Washington's inauguration as first President of the United States is received today. The Georgia Gazette is quoted as follows: *"New York, May 1st 1789—Yesterday at two o'clock was solemnly inaugurated our illustrious President."*

Nov. 26 — The first national Thanksgiving Day is observed in Savannah. The Georgia Gazette of December 3rd shows that *"Thursday last was observed here as a Day of Thanksgiving and Prayer in compliance with the proclamation of the President of the United States."*

1790

March — The first meeting of Council takes place and John Houstoun is elected Mayor. Meetings are called each

Tuesday morning at 10 o'clock, and any member more than ten minutes late is *"fined for every minute's absence, one penny."*

May 13

The Georgia Gazette has the following notice: *"Philadelphia April 23—On Saturday night departed this life, in the 85th year of his age,* DR. BENJAMIN FRANKLIN *of this city, It is computed that not less than 20,000 persons attended the funeral."*

May

The following resolution is passed at the meeting of Council: *"That Decency and Humanity demand that the Burying ground be enclosed immediately, and we are of the opinion that the wall six feet high, with stone every fifteen feet would answer the purpose."* As a result this item is included in the first city budget presented May 18: *"Enclosing the Burying ground £600."* Recorded at the same meeting is a *"Subscription of the ladies for enclosing the Burying ground £80."*

Aug. 12

To the Hebrew congregation of Savannah belongs the honor of having received an answer to their letter of congratulation to President George Washington upon his inauguration. From the letter, written by Levi Sheftall, president of the Synagogue, the following is quoted as published in the Georgia Gazette of this date: ... *"We have been long anxious of congratulating you on your appointment by unanimous approbation, to the Presidential dignity of this country, ... Our eccentric situation added to a diffidence founded on the most profound respect has thus long prevented our*

address.... Your unexampled liberality and extensive philanthropy have dispelled that cloud of bigotry and superstition which has long as a veil shaded religion, unrivetted fetters of enthusiasm, and enfranchised us with all the privileges and immunities of free citizens."

To which the President replies in part: *"I thank you with great sincerity for your congratulation on my appointment to the office, which I have the honor to hold by the unanimous choice of my fellow citizens.... I rejoice that a spirit of liberality and philanthropy is much more prevalent than it formerly was among the enlightened nations of the earth, and that your brethren will benefit thereby in proportion as it shall become still more extensive... May the same wonder-working Deity who long since delivered the Hebrews from their Egyptian oppressors, planted them in a promised land still continue to water them with the dews of heaven and make the inhabitants of every denomination participate in the temporal and spiritual blessings of that people whose God is Jehovah.*

<div align="right">*G. Washington."*</div>

From the *"Rules and Regulations for the Dancing Assembly of Savannah"* printed at this time these two rules are quoted:

"No card playing until the County Dances begin.
"No Gentleman to be admitted in Boots."

The congregation Mickve Israel receives its charter signed by Governor Telfair.

Nov.

Nov. 30

1791

March 2

John Wesley dies in London in his eighty-eighth year. Due to the outgrowth of his teachings which originated in Oxford in 1729 within a small society created by William Morgan for religious study, and whose members had earned for themselves among other nicknames the title of *"Methodists"*, Wesley's religious influence has been such as not only to convert through his power of organization one hundred thousand to Methodism during his lifetime, but also to awaken England from her religious lethargy in an era which had drawn the following graphic observation from Hannah More: *"We saw but one Bible in Cheddar, and that was used to prop a flower-pot."*

March 9

Thomas Gibbons is elected second Mayor of Savannah.

May 12

President George Washington visits Savannah. The Georgia Gazette of May 19th says: *"On Thursday morning the President arrived at Purysburg where he was received by a Committee... he embarked at Purysburg between ten and eleven o'clock and was rowed down the river by nine American captains ... dressed in light blue silk jackets, black satin breeches, white silk stockings, and round hats with black ribbons having the words 'Long Live the President' in letters of gold."*

During his stay, Washington, accompanied by General McIntosh, inspects the line of defense constructed

by the British in 1779, while on Sunday he attends the service at Christ Church. Many elaborate entertainments are given in his honor, among them a dinner by the Society of the Cincinnati of Georgia at Brown's Coffee House, as well as a ball in the Long Room of the Filature *"where he is introduced to ninety-six ladies who were elegantly dressed, some of whom displayed infinite taste in the emblems and devices on their sashes and head-dresses out of respect to the happy occasion"*. Washington's appreciation of the *"Fair Sex of our City and vicinity"* is shown in his Journal, when he says, referring to this event *"In the evening went to a dancing Assembly at which there was about 100 well dressed and handsome ladies."* On his departure for Augusta he visits Mulberry Grove.

That George Washington makes a memorable impression in Savannah is seen from the following tribute: *"Every one beheld with delight in the person of our President the able General, the virtuous Patriot, the profound Politician; in a word one of the most shining ornaments that ever dignified human nature."*

1792

Joseph Habersham becomes Mayor of Savannah.

Nov.

Repeated notices appear in the Georgia Gazette of this period stating that on *"Tuesday morning the Lantern of the Light-House on Tybee took fire and was entirely consumed. In consequence no light can appear for some time."*

THE SEVENTH WATCH
Grey Horizons
1793--1802

ANCHORED YESTERDAYS	91

	1793
Joseph Habersham is appointed Postmaster General of the United States by President Washington.	
From the Georgia Gazette: *"On Monday last the Aldermen of this City met agreeably to law, when William Stephens Esqr. was elected Mayor.*	*March 4*
The news of the re-election of President Washington appears in the following item in the Georgia Gazette: *"The President of the Senate declares George Washington President of the United States, by an unanimous vote and John Adams Vice-President by a majority of votes."*	*March 14*
James Jackson is elected United States Senator from Georgia in this year.	
Eli Whitney, a Massachusetts school teacher, while on a visit to the widow of General Greene at Mulberry Grove, perfects the first practical and salable cotton gin, becoming its recognized inventor.	
The "Georgia Journal and Independent Federal Register" is issued.	*Dec. 4*
	1794
The population within the city limits is estimated at 2,500.	
Thomas Gibbons is again elected Mayor.	*March 10*

1795	
March	William Stephens is again elected Mayor of Savannah.

James Jackson resigns as United States Senator to return to Georgia for the purpose of defeating the frauds culminating in the infamous "Yazoo Act" approved Jan. 7th, 1795. He is elected to the Legislature from Chatham County. |
1796	
Feb. 13	The bill known as the "Rescinding Act", introduced in the Legislature by James Jackson, is passed and declares the sale of Yazoo lands by previous legislation as *"not binding and authorizing moneys be returned."*
March 4	The "Columbian Museum and Savannah Advertiser" makes its first appearance as a semi-weekly newspaper.
March 14	John Y. Noel is elected Mayor.
Aug. 6	Various steps for protection against fire are taken about this time. Bids are called for the sinking of public wells in the squares, the Friendly Fire Club cooperates with the city officials, new fire engines are bought, and a fire engine house is built on Watch House lot. On this day the first review of the fire department takes place, each fireman's uniform being *"a robin or close jacket of blue cloth, overalls of the same, and a leather cap."*

YESTERDAYS

From the Georgia Gazette: *"Saturday, the 1st of October being the anniversary of the Savannah Golf Club, the members are requested to attend at the Merchants and Planters Coffee House on that evening at 6 o'clock for the purpose of electing officers for the ensuing twelve months and to transact other necessary business."*
Sept. 22

Announcement is made in the Columbian Museum that *"the New Theatre in Savannah"* will be opened with the *"favorite comedy, 'The Contrast'."*
Oct. 21

An advertisement in the Columbian Museum shows the existence of a *"School for Dancing, Mr. Goodwin is fitting up a commodious room for the reception of those young misses and masters whose respective parents may honor him with their patronage."* Among the dances taught by Mr. Goodwin is *"The new Mode in Dancing the Minuet, (with the graceful baulk in offering hands)."* The terms are stated as follows: *"Four Dollars at Entrance, and Six Dollars per Quarter, payable monthly—which Mr. Goodwin will receive in Domestic articles, or orders for such."*

Savannah's first devastating fire is thus described in the Columbian Museum: *"On Saturday the 26th inst. this city exhibited a scene of desolation and distress, probably, more awfully calamitous than any, previously experienced in America—in four hours 229 houses, besides outhouses, etc., were burnt, amounting to One Million of Dollars, exclusive of loose property— 375 Chimneys are standing bare, and form a dismal*
Nov. 29

appearance—171 houses only, of the compact part of the City are standing—upward of 400 families are destitute of houses. Charities are solicited."

Christ Church is among the buildings destroyed.

1797

March 24

The Columbian Museum in its Philadelphia news of March 4 in announcing that *"his Excellency John Adams Esq. this day in the Representative Chamber takes the oath of office as President of the United States"* has also the following: *"Melancholy, Very Melancholy Indeed! Died, last evening, of a two years consumption and under all the horrors of a guilty conscience, the House of Representatives of the United States."*

July 10

John Glen is elected Mayor.

1798

James Jackson is elected Governor of Georgia. Ten years before he had declined the same office, saying he was too young for this honor.

Georgia's third Constitution is adopted, one of its most interesting clauses being the prohibition of the African slave trade.

A circulating library is started in Savannah by George Lamb.

July 9

Matthew McAllister is elected Mayor.

YESTERDAYS

1799

June 4

The building of the City Exchange is planned by a joint stock company. The Georgia Gazette of June 5th says: *"Yesterday the Corner Stone of the City Exchange was laid by the Right Worshipful the Honourable William Stephens, Grand Master of Masons in this State, where the former one (destroyed by the fire of 1796) was erected."*

July 8

Thomas Gibbons is again elected Mayor.

1800

Jan. 9

The first year of this new century sees the nation's capital moved to Washington, D. C., and brings the news of George Washington's death to Georgia, which reaches Savannah in its first month. The Georgia Gazette says in part: *"Philadelphia Dec. 19, 1799. On Saturday, the 14th inst. died at his seat in Virginia, Gen. George Washington, Commander-in-Chief of the Armies of the United States of America, Mature in years, covered with glory, and rich in the affection of the American people.*

Savannah

All shipping on Sunday last hoisted colors at half mast . . . the Mayor and Aldermen resolved to wear mourning for 1 month They also recommended all merchants and shopkeepers and tradesmen to close for 3 days which they did. A funeral sermon will be preached Sunday next by Rev. Mr Holcombe."

July 14	The census for this year shows Savannah to have a population of 5,166.

Thomas Gibbons is re-elected Mayor. |
1801	
March 24	The Columbian Museum in its Washington news, dated March 4, says in part: *"This day at 12 o'clock, Thomas Jefferson, President of the United States took the oath of office,"* while in its local *"Communications"* it announces the following: *"Republican Citizens! The Festival in commemoration of the election of Thomas Jefferson, will be given on Thursday the 26th inst. under a booth, to be erected for that purpose, on the South Common."*
July 13	David B. Mitchell is elected Mayor.
Dec. 22	From the Columbian Museum is quoted the following: *"A number of Ladies residing in this City & vicinity, having lately made a liberal subscription for establishing an institution, ...* CONVENED *on Thursday last, in the Presbyterian Church.It was agreed that the institution should be known by the name of the Savannah Female Asylum."*
1802	
	Savannah's *"nocturnal amusements"* of this period are alluded to in the following manner by the Rev. Mr. Henry Holcombe in a letter included in his book *"First Fruits":*

YESTERDAYS

"My dear Brother: In the course of the year 1802 I had to encounter a detachment of his Satanic majesty's forces, called 'Stage players'. They sat themselves in direct opposition to the interest of our Master's kingdom in Savannah, and fortified a garrison not fifty yards from a post I occupied at the time, called the 'Baptist meeting-house'."

Aaron Burr, vice president of the United States, arrives in Savannah and stays at the home of his niece, Mrs. Montmollin. Among the entertainments given in his honor is a dinner at the City Hall. After a visit of nearly a week he leaves *"the city on his return to the Northward, being saluted by the guns of the revenue cutter on his departure."*

Charles Harris is elected Mayor.

May 20

July 12

THE EIGHTH WATCH
White Caps
1803--1812

ANCHORED YESTERDAYS

1803

Feb. 21

A city ordinance passed on this day reads: *"Whereas, the names or titles of King, Prince, or Duke are unknown to the institutions of Georgia, or the United States and the permitting or suffering several streets in this city to be still called by those obnoxious names reflects highly on the police thereof, be it therefore ordained by the Mayor and Aldermen of the City of Savannah that, King Street shall be called President Street, Prince Street shall be called State Street and Duke Street shall be called Congress Street."*

July 11

Charles Harris is re-elected Mayor.

Oct. 29

The first official record of deaths and burials in the city is begun.

1804

Jan.

During this year Rembrant Peale, who is to become one of America's most distinguished portrait painters, visits Savannah with his brother, Raphaelle, staying at Mr. Fowler's on Broughton and Lincoln Streets.

In the newspapers of the period appear advertisements from both brothers. The Columbian Museum is quoted as follows: *" Patent Profiles Prices (as hitherto) 25 cts. for four. Portraits in miniature 30 and in oils 50 dollars.*

Raphaelle Peale"

Rembrant Peale advertises *"Wanted for the Exhibition of the Mammoth a decent room, at least 18 feet square, "*

Of unusual interest, therefore, is the novel combination included in the resolution passed by Council, [who for about ten years had been issuing licenses covering various forms of amusements,] which gives *"permission to Rembrant Peale to show the skeleton of the mammoth, and it is allowed that the learned goat may also be shown for the amusement of the inhabitants."*

May 5

From the Columbian Museum: *"The remains of our late Governor Tattnall were received here on Monday last from New-Providence where he went in the spring of 1803 for the recovery of his health, and died the following June, a funeral procession was formed on Tuesday. . . "*

According to his last request, his body is buried at Bonaventure, the home of the Tattnalls. This historic plantation, confiscated in Revolutionary times due to the royalist sympathies of the Tattnalls and Mulrynes, had been restored to Josiah Tattnall, whose loyal attachment to his state had never wavered and who in defiance of parental authority had returned to the colony where he had joined the forces of General Greene.

July 9

John Y. Noel is again elected Mayor.

YESTERDAYS

A terrific hurricane, raging for more than twelve hours, causes death and destruction. Many houses, among which are the Exchange, the Filature, the Jail and the Court House, are injured, and a number of vessels are blown ashore.

Sept. 8

The following organization is incorporated under the style and name of *"The Georgia Medical Society, for the purpose of lessening the fatality induced by climate and incidental causes, and improving the science of medicine."* The officers chosen are: Noble Wimberly Jones, President; John Ervine, Vice President; John Grimes, Secretary, and Lemuel Kollock, Treasurer.

Dec. 12

1805

Official mention is made of inoculation for smallpox, when the mayor has *"the pleasure to inform Council that by means of a small quantity of matter lately received the vaccine inoculation has taken place and is now prevailing within the city."*

Feb. 25

John Y. Noel is re-elected Mayor.

July 8

1806

This day marks the death of James Jackson, patriot and statesman.

Jan. 19

John Y. Noel is again elected Mayor.

July 14

1807

March 10

The Georgia Republican under a joint ownership is issued as a tri-weekly, under the name of "The Republican and Savannah Evening Ledger."

May 7

Edward G. Malbone, portrait painter, dies in Savannah at the age of thirty, and is buried in the Colonial Cemetery. From the city's record of deaths and burials, the following is quoted: *"Edward G. Malbone—Artist in painting Likenesses—died of Consumption May 7th—Buried May 8, 1807."* Giving Newport, Rhode Island, as his home, the *"Remarks"* add that *"Some of his productions are said to have gained him high applause from the celebrated West of London. He died at, and was buried from the House of Rt' Mackay Esq."*

Sept. 14

William Davis is elected Mayor. (Resigns).

Nov. 30

Charles Harris is elected Mayor.

1808

Sept. 12

John P. Williamson is elected Mayor.

Dec. 23

Owing to many reverses, Bethesda is sold by an act of the Legislature and the proceeds are divided among the Savannah Poor House and Hospital, the Union Society, and the Chatham Academy.

YESTERDAYS

1809

"The Life of General James Jackson," by Judge T. U. P. Charlton, is published in this year.

The Republican and Savannah Evening Ledger in its Washington news, dated March 4th, says: *"This day at 12 o'clock JAMES MADISON took the oath of office as President of the United States."* — March 15

William B. Bulloch is elected Mayor. — Sept. 11

1810

Savannah's census shows a population of 5,215.

The Savannah Public Library is established. — March 6

William B. Bulloch is re-elected Mayor. — Sept. 10

1811

Thomas Mendenhall is elected Mayor (Resigns). — Sept. 6

William B. Bulloch is elected Mayor. — Oct. 25

During the war between France and England, the presence of two French privateersmen causes a serious riot when attempts are made at recruiting, and results in the burning of both ships, LaVengeance and LaFrancaise, with casualties on both sides. — Nov.

Dec. 31	New Year's Eve is the occasion of a Golf Club Ball in Savannah. The following is a copy of an invitation sent on December 20th and signed by the Managers: *"The honor of Miss Eliza Johnson's Company is requested to a Ball, to be given by the Members of the Golf Club, of this City, at the Exchange on Tuesday Evening, the 31st instant. at 7 o'clock."*
1812	
	The first volume of *"The History of Georgia"* by Captain Hugh McCall is published.
Jan 28	Anticipation of conflict with England is shown by a notice which appears in the Savannah Republican. The people are asked to meet on Thursday next in the Roman Catholic Church *"to beseech the Father of Mercies to avert from this nation the calamities which threaten it."*
March 17	The Hibernian Society is organized.
April	Josiah Tattnall, the future Confederate Commodore, receives his appointment as midshipman. He is destined to become famous when in 1859, using the memorable phrase "Blood is thicker than water" he goes to the assistance of the British ships at the mouth of the Pei-Ho River.
June 25	The announcement of the declaration of war between the United States and England, on June 19th,

reaches Savannah and immediate preparations are made to fortify the city.

George Jones is elected Mayor.

Sept. 14

THE NINTH WATCH
Steaming Ahead
1813--1822

	1813
The American victories in northern waters are hailed with joy in Savannah, and the city council sets aside this day as one of celebration when the citizens *"can give expression of their gratitude to the Supreme Being for the aforesaid signal victories."*	Jan. 1
The Chatham Academy is formally opened, two hundred and nineteen pupils are present the first day.	Jan. 5
A meeting of the citizens is held and they resolve to raise $40,000 for *"effectually defending the city against the attack of the enemy."*	June 2
A Committee of Vigilance is appointed to *"carry into effect the Act of Assembly against idle and disorderly persons having no visible estate or lawful employment."*	July 29
George Jones is re-elected Mayor.	Sept. 13
	1814
The British brig "Epervier" having been captured by the U. S. sloop "Peacock" is brought into port. On board is specie amounting to $110,000 which is confiscated and distributed according to law.	May
Matthew McAllister is again elected Mayor (Resigns).	Sept. 12
Upon the arrival of Brig. General Floyd with a considerable military force the Committee of Vigilance is temporarily disbanded. However, agitation contin-	Dec.

ues in anticipation of possible attack. Further measures of defense are adopted.

1815

Jan. 26 — The Columbian Museum has the following notice: *"The times are eventful—the Enemy threatens—Citizens guard your Rights—act with energy, and we are safe. the* FORTIFICATIONS *around our City are progressing with the greatest rapidity."*

Feb. 21 — City Council tenders formal thanks to General Andrew Jackson on his victory at the battle of New Orleans, Jan. 8th.

Feb. 28 — Upon President Madison's Proclamation of Peace, the following notice is published: " . . . *"The Citizens of Savannah are respectfully invited to set aside Saturday next, of March, as a day for innocent recreation and amusement in consequence of the ratification of the Treaty of Peace with Great Britain, founded on a Basis of perfect reciprocity and honorable to this Nation. . ."*

April 24 — Thomas U. P. Charlton is elected Mayor.

The Methodist Church, known as Wesley Chapel, is completed and dedicated.

Sept. 11 — T. U. P. Charlton is re-elected Mayor.

ANCHORED	113

| | 1816 |

The second volume of The History of Georgia by Captain Hugh McCall is published.

Within ten years of Robert Fulton's invention of the steamboat the first steamer in Georgia, owned by Mr. Howard of Savannah is used for river transportation. The Savannah "Republican" contains this notice: *"The steamboat 'Enterprise' with a numerous concourse of citizens on board, started from Howard's wharf yesterday morning, To behold a large and apparently unwieldy machine, without oars or sails, propelled through the element by an invisible agency at a rate of four miles an hour is indeed a novel spectacle."*

April

T. U. P. Charlton is again elected Mayor.

Sept. 9

| | 1817 |

The first issue of the first daily newspaper, the "Savannah Gazette", appears, and in it is the following interesting notice: *"A corner stone for a new Presbyterian Church was laid in this city yesterday."* John H. Green, architect of the church, models his plans after *"the church of St. Martin-in-the-Fields"* in London.

Jan. 14

The "Savannah Gazette" combines with "The Columbian Museum and Savannah Advertiser."

Feb. 3

The first mention of the Georgia Hussars is the record of their parade which takes place on this day.

Feb. 22

This troop, formed from the Light Dragoons and the Chatham Hussars, is probably the outgrowth of the rangers and dragoons of Colonial days.

March 12

The news of President Monroe's inauguration reaches Savannah on this day and is published in the Columbian Museum and Savannah Daily Gazette in the following words without mentioning the President's name: *"From the National Intelligencer—Extra March 4—This day at 12 o'clock in the presence of the senate and most of the representatives in congress, and a large concourse of citizens and strangers the President of the United States took the oath of office."*

Sept. 8

James M. Wayne is elected Mayor.

1818

Sept. 14

James M. Wayne is re-elected Mayor (Resigns).

Nov. 25

The "Savannah Georgian" is issued under the brief editorship of Dr. John M. Harney. An erratic iconoclast he is perhaps best known by his leave taking when he crowds the violence of his feelings into his "Curse upon Savannah", from which is quoted the last few lines:

"May all your free citizens, wealthy or poor
Be bribed for their votes, as they have heretofore!
May every quack Doctor be patronized still,
And his talents be judged by the length of his bill;

*May all your quack Lawyers find themes for their tongues
And their brains get the applause that is due to their lungs;
May your miserly merchants still cheat for their pence,
And, with scarce any brains show a good deal of cents!
Now, to finish my curses upon your ill city,
And express in few words all the sum of my ditty,
I leave you, Savannah—a curse that is far
The worst of all curses,—to remain as you are!"*

The completion of the theatre, destined to continue as Savannah's playhouse in modern times, is referred to in the Columbian Museum: *"We congratulate the citizens of Savannah on the arrival of the Theatrical Corps, and on the prospect of an early opening of the New Theatre".* In the same paper appears the following advertisement: *"*THEATRE,—*The Manager has the pleasure of respectfully informing the public that the New Theatre will open on Friday, December 4th 1818 with Cherry's Comedy of 'The Soldier's Daughter'."*

At the suggestion of Captain Moses Rogers, several business men, with William Scarborough at their head, form a steamship company. They order a combination steam and sailing vessel, intended for trans-Atlantic service, to be constructed in New York, and name her the "Savannah."

Dec. 3

1819

Jan. 5

The Georgian has the following unusual advertisement: *"The Greatest Natural Curiosity—Now exhibited in America—A living Elephant is now to be seen in Jefferson Street, It is not only the most sagacious animal in the world; but from the peculiar manner in which it takes its food and drink of all kinds with its trunk, is acknowledged to be the greatest natural curiosity ever offered to the public."*

Feb.

From the Georgian of this month is quoted the following interesting advertisement:

"Introduction of Ice into Savannah—The inhabitants of this city are informed that a large and expensive Ice-House is now completed..... It is intended to offer this article for sale at the low price of SIX AND A QUARTER CENTS *the pound...... Ice cannot be used with any permanent advantage without a* PORTABLE ICE-HOUSE *or refrigerator ... which articles are for sale at the Ice-House ... with one of them wine, water, butter, milk, fruit, &c may be preserved continually cold with from four to seven pounds of Ice daily..... The Ice decanter for preserving wine cool after it is placed on the table is also offered for sale."* This lengthy advertisement ends with a request for subscribers *"so that some calculations may be made respecting the probable demand, and to know whether it will be expedient to fill the house with Ice by importing a second cargo."*

April

The "Savannah" in command of Captain Moses Rogers arrives from New York. The following is quoted from her Log which is in the National Museum in Washington: *"Remarks on board Tuesday April 6th, 1819—at 10 Calm we shiped the wheels and put Steam on and went in over the bar and took a Pilot on board at 4 Come to anchor of the town of Savannah."*

May 8

President Monroe, accompanied by Mr. Calhoun, Secretary of War, and General Gaines, visits Savannah and remains five days as the guest of William Scarborough.

May 9

The Columbian Museum and Savannah Daily Gazette of May 10th says in part: *"Yesterday the New Independent Presbyterian Church ... was solemnly dedicated to the service of Almighty God. ... It is seldom that we discover a scene more affecting and impressive than this solemn ceremony afforded, and in this city we never witnessed such an immense congregation so large a portion of which was formed of female beauty; also the President of the United States and Suite and other distinguished personages belonging to the Army and Navy. the performance of the vocal music tended to elevate the soul to sublime and heavenly musings. The respectful attention and the fervency of the responses all combined to induce the belief that the heart accompanied the lips in supplication to the throne of Divine Grace."*

May 12

The President and his suite, with the city officials, enjoy a trip to Tybee on board the "Savannah."

May 20	The first steamship to cross any ocean is the "Savannah" which sails on this day bound for Liverpool, making the trip in 29 days and 11 hours. Off the coast of England the revenue cutter "Kite" hastens to her aid believing her to be on fire however, to the surprise and admiration of the people who crowd the banks of the Mersey she steams up the river *"belching forth smoke and fire, yet uninjured."* Her arrival in Liverpool is recorded in her Log as follows: *"Sunday 20th, 1819—At 2 P. M. hove too off the bar for the tide to rise—at 5 P. M. Shiped the wheels and firl'd the sails and run in to the River Murcer. At 6 P. M. come to anchor off Liverpool with the small Bower Anchor."*
July 12	T. U. P. Charlton is elected Mayor.
Sept. 13	T. U. P. Charlton is again elected Mayor.
Nov. 20	The "Savannah" returns from her successful voyage which had extended as far as St. Petersburg, with a stop at Elsinor, where she had been visited by the Prince of Sweden as well as by many Swedish and Russian nobles.
1820	
Jan 11	A second destructive fire sweeps over the city. The "Georgian" of Jan. 17th. gives this account: " *Ninety lots were left naked, containing three hundred and twenty-one wooden buildings, many, often double*

tenements, thirty-five brick, four hundred and sixty-three buildings exclusive of out buildings. The estimated loss upwards of four million. Alas, never did the sun set on a gloomier day for Savannah, or on so many aching hearts."

The corner stone of the Synagogue is laid. April 20

A disastrous epidemic results from the arrival of a vessel from the West Indies with yellow fever on board. The following figures show the extent of its devastation. With a population of 7,523, nearly 6,000 leave the city. Unoccupied houses number 375. In five months 695 deaths from yellow fever are reported. An interesting glimpse into the scientific causes of yellow fever is given in a report made to Council by Dr. W. R. Waring, as alderman, Jan. 17, 1821. He says in part: "*. . . . the causes of fever have been: A general epidemic condition of the atmosphere either proved to exist, or produced by an uncommon deficiency of the electric fluid; the reduction of the winter 19-20 to the temperature of spring, and the reduction of spring to the heat of summer. . . . The prevalence of easterly winds. . . The unnecessary luxuriance of the trees by the shade and protection which they afford to dews and fogs. . . . The great number of small wooden houses . . . in a complete state of putrescence. Uncovered vaults and cellars, the consequence of the fire. . . . All these causes together give a compound origin to the disease, which is internal and external.*" Sept. 5

Sept. 11	T. U. P. Charlton is again elected Mayor (Resigns).
1821	
Feb. 23	James Morrison is elected Mayor.
Sept. 21	James Morrison is re-elected Mayor.
Dec.	Pay for the office of Mayor is first considered when an ordinance is passed, allowing the Mayor a salary annually, the amount being later fixed at $1,000.
1822	
Jan. 1	Organized this day, *"The Savannah Widows' Society for the relief of indigent widows with families, and other destitute females."* [Later it becomes merged into the "Abrahams' Home."]
Sept. 5	James Morrison is re-elected Mayor.

THE TENTH WATCH
The Tricolor,--Ahoy!
1823--1833

1823
Jan. 9

For several years it has been apparent that the rice fields and undrained lands immediately adjacent to the city are responsible for the increasing autumnal diseases. Official recognition of the prevailing menace is taken at the instigation of the Georgia Medical Society when Council refuses to sanction contracts which oppose the recently adopted system of dry culture of rice. Mortality statistics under wet culture for a period of three years show one in eleven, while the average for the first period under dry culture is one in twenty-seven,—in the second period one in thirty-five.

Sept. 4

James Morrison is re-elected Mayor.

1824
Jan. 29

Health conditions under dry culture are expressed in a report made to Council: *"Six years have passed away under the operation of the dry culture system. Imperfectly as that system has been enforced it has given evidence the most conclusive of a favorable influence upon the health of Savannah. Nothing formerly was better calculated to impress upon the mind of a stranger arriving here in November, the melancholy character of our climate, than the bleached and sallow faces of our inhabitants. The remark is now general that of late faces are quite as indicative of*

health as those of persons residing in cities to the North. . . . The report further states that the inhabitants show greater *'corporeal vigor'."*

Sept. 13

William C. Daniell is elected Mayor.

1825

March 10

Of interest are the two following items of news which appear in the Georgian: *"The Pirates who have been confined in Chatham County Jail since the summer of 1821 . . . have received a pardon from the President of the U. S. They were sentenced to be hung in April 1822, but were respited during the pleasure of the President."*

"THE INFLUENZA, *In the city of New York, it has kept in constant attendance the physicians, from whose reports, it appears, that from 40 to 50,000 people are suffering."*

March 14

The Georgian in quoting from the Phenix Gazette Extra, Alexandria—March 4, gives the inaugural address as *"delivered in the Hall of the House of Representatives by John Quincy Adams, on taking the oath as President."*

In anticipation of General Lafayette's visit the following notice appears in the same newspaper: *"The citizens of Savannah are respectfully requested, as much as possible, to confine to their own yards and*

houses, their servants and especially the children, whilst military honors are paying to General Lafayette."

General Lafayette, the *"Nation's Guest"*, styled by Carlyle *"the hero of two continents"* visits Savannah. Following is an extract from one of the daily papers: "This happy event took place on Saturday, the nineteenth of March..... The first notice of the arrival of the welcome vessel was by a few strokes of the Exchange Bell..... As the Steamboat passed Fort Jackson, she was boarded by the Committee of Reception. On their ascending the deck the General was addressed by their chairman, George Jones Esq. The boat now came up in gallant style, firing by the way, and a full band of music on board playing the Marseillaise Hymn, and other favorite French and American airs..... As the General placed his foot upon the landing place, a Salute was fired by the Chatham Artillery in line on the Bluff..... He was here received by William C. Daniell Esq. Mayor of the city..... On arriving on the top of the Bluff, on the green he was presented to Governor Troup by whom, in the most cordial manner he was welcomed to the soil of Georgia."

March 19

While in Savannah General Lafayette and Governor Troup are the guests of Mrs. Maxwell at 124 Abercorn Street. On the 21st, with Masonic ceremonies Lafayette lays the cornerstones for the two proposed monuments, one to General Nathaniel Greene in Johnson Square; the other to Count Pulaski in Chippewa

Square, the latter for want of sufficient funds is not completed as planned.

Among the numbers of people that the General meets on his triumphal tour, he seems particularly interested in one who greets him here. To quote from Levasseur's "Lafayette in America": *"We found in Savannah a young man whose name and destiny were to inspire us with a lively interest, Achille Murat, son of Joachim Ex-King of Naples. On hearing Lafayette was in Georgia he precipitately quitted Florida where he was a planter and came to add his homage and felicitations to those of the Americans, his countrymen, as he was now a naturalized citizen."*

Sept. 8

William C. Daniell is re-elected Mayor.

1826

Jan. 26

At the request of Council a bill had been put through the Legislature prohibiting the wet culture of rice within two miles of the city, and an ordinance is passed in accordance with this prohibition. A report shows that *"The atmosphere has maintained a character of clearness and elasticity which it has only acquired since the introduction of the dry culture system."*

Sept. 11

Joseph W. Jackson is elected Mayor.

1827

Since the first treaty between Oglethorpe and the Creeks, signed in May, 1733, nearly a century has elapsed. In this year, due to the aggressive stand taken by Governor Troup, President John Quincy Adams withdraws his active opposition and influences the Creeks to cede their last strip of territory in the state, and a final treaty is signed which marks the removal of the Creek Indians from Georgia.

Joseph W. Jackson is re-elected **Mayor**. *Sept. 10*

1828

William T. Williams is elected **Mayor**. *Sept. 8*

1829

The Georgian has the following: *"The Inauguration of General Jackson took place on the 14th instant a letter from Washington says of the President 'The enthusiasm with which he was received cannot be described, nor the striking beauty and magnificence of the whole scene'."* *March 14*

John McPherson Berrien is appointed Attorney General in the cabinet of President Andrew Jackson. As United States Senator, his oratorical powers had won for him the title of the *"American Cicero."*

Sept. 14
1830

William T. Williams is re-elected Mayor.

The United States census gives Savannah's population as 7,776.

Sept. 13
1831

William R. Waring is elected Mayor.

The erection of Fort Pulaski is begun.

Sept. 12
1832

Wiliam R. Waring is re-elected Mayor.

Insufficient police protection and the withdrawal of most of the troops during the summer months cause Council to petition the Secretary of War for permanent military barracks within the city. As a result orders are issued and temporary barracks are established in the Savannah Theatre during the summer of this year.

Sept. 10

George W. Owens is elected Mayor (Resigns).

The Georgia Infirmary is incorporated by an act of the Legislature which originates from a bequest made by Thomas F. Williams *"to be paid to the first incorporated Body for the Relief and Protection of afflicted and aged Africans."* Richard F. Williams, in executing his brother's wishes, further states in his petition to the Legislature *"that he as present owner of the tract of land in which the Rev. Mr. Whitefield created Bethesda College known as the Orphan House in Chatham County, will give Fifty acres of the same in fee simple with all the Buildings and appurtenances therein, for the location, and use of such an institution."* The charter is granted and signed by Governor Lumpkin.

| Dec. 24 |

| 1833 |

From the Georgian: *"At a numerous and respectable meeting of the citizens of Savannah, held at the Exchange last evening for the purpose of making arrangements for the Centennial celebration of the Landing of Oglethorpe in Georgia, George Jones was called to the Chair, & Rich'd W. Habersham appointed Secretary."*

| Jan. 1 |

From the Georgian: *"This being a day which occurs but once in a hundred years, our patrons will excuse us for not issuing a paper to morrow in order to allow our hands to join in the general celebration. We promise not to be guilty of the same offense at the next* CENTENNIAL. *At that time, our type will be* SET, *our*

| Feb. 12 |

PROOF SHEET READ and CORRECTED, and as we sincerely hope, our FORM JUSTIFIED, and LOCKED UP, and REVISED with the approving smile of our ALL seeing Patron."

Feb. 14

From the Georgian: "On Tuesday the 12th inst. the Centennial Anniversary of Oglethorpe's first landing on the banks of the Savannah for the purpose of founding the Colony of Georgia, was celebrated in this city in a becoming and spirited manner.

.... At ten o'clock ... the Hussars, the Artillery, ... the Riflemen, ... the Blues, ... and the Guards, formed on the right of the Exchange, as the escort of the procession consisting of the Orator, and the Reciter of the Ode, with the Committee, the Reverend Clergy of the city, the descendants of those who accompanied Oglethorpe to Georgia, Foreign Consuls and Agents, the Judges of the several Courts, ... the Corporation of the City and officers, the Officers of the Army and Navy, the Field, Staff, and Commission officers of the First Regiment and the neighboring Battalion, the Collector of the Port and officers, the Union, Hibernian and St. Andrew's Societies, Ship Masters, Pilots of the Port, Citizens, and Boys.

"The procession moved to the Methodist Church, which, with commendable patriotism had been lent for the occasion. After an address to the Throne of Grace from the Rev. Mr. Pierce of that Church, Robert M. Charlton Esqr. recited an Ode written by himself for the occasion, ... His MANNER of delivery, and his

MATTER *elicited from his delighted auditory frequent bursts of approbation.*

"After the recital of the Ode Matthew Hall McAllister Esqr. pronounced an Oration in every respect suited to the day. It has never fallen to our lot to be more pleased on any occasion than we were with the spirit stirring production of both the Orator and the Poet, we trust that they will be given to the Public as of right their Property, and not from a fastidious delicacy be witheld from their fellow citizens.

"The Church was crowded. The Patriotic Fair in numbers successively cheered with their happy smiles the Poet and Orator, and inspired the citizen soldier with renewed determination to guard with jealous anxiety those Institutions which are the pride and bulwark of our Country.

"The Military marched to the lower end of the Bluff that received the first footsteps of Oglethorpe, where a salute of one hundred guns was fired by the Chatham Artillery from two pieces of Cannon captured at Yorktown, and presented them by General Washington. Salute and a feu de joie were then fired by the Riflemen and Infantry. A brilliant and crowded Ball closed the celebration of the day.

"It was emphatically a proud day for Savannah."

AFTERWORD
Anchored Yesterdays and Its Authors
WILLIAM HARRIS BRAGG

In late December 1923 a columnist for a Savannah newspaper announced, "We have all been tremendously interested this week in the publication of the little volume of Georgia history, just off the press—*Anchored Yesterdays* from the pens of Elfrida De Renne Barrow and Laura Palmer Bell, for it is a holiday event of much more than usual interest and importance."[1]

Indeed it was. The book itself (of which the present edition is a close facsimile) possessed attractions of both form and content. Almost square at approximately 6½"× 8", the book appeared in "gray board covers" with a "green-on-white title label" on its front. The label offered an artistic rendering of the book's evocative, imagist title, beneath which rode a graceful frigate under full sail, representing the *Anne*, the ship that brought the first colonists to Georgia in 1733. This nautical motif, appropriate for Georgia's port city, continued throughout the book. Interior illustrations—Bell's work, like the cover—included such ornaments as anchors, seashells, and, at the head of each chapter, a "Sea Mark": a drawing of Georgia's first lighthouse, Tybee Light.[2]

Complementing its ornamentation, the book's layout and text also emphasized seafaring imagery. The book's subtitle announced it as "The Log Book of Savannah's Voyage Across a Georgia Century, in Ten Watches," and its pages were "lined and printed as a log book . . . , with dates in the margin." The "Watches" of the subtitle represented the authors' designations for their chapters. Instead of the two- to four-hour watches a ship's company kept vigil during each day and night, the watches in *Anchored Yesterdays* each comprised a decade and reported chronologically the notable historical events of those periods. The first watch began with the *Anne*'s arrival off Charleston bar in 1733; the last one ended with Savannah's centennial festivities in 1833.[3]

The titles of the watches likewise evoked the sea (as did "Laying the Keel," the title of the preface, which admirably summarized the events in England that

led to Georgia's founding). Reflecting the fact that ships of the period flew a flag called the blue peter when preparing to sail, the first watch bore the title "Hoisting the Blue Peter," and succeeding watches carried similarly appropriate nautical titles. Among them were "Slack Tide," for the static years that saw the Georgia Trustees' colonial experiment founder; "Storm Circled," assigned to the tumultuous revolutionary epoch; and, in keeping with the portentous voyage of a later decade, "Steaming Ahead," which included the transatlantic adventure of the steam-powered *Savannah*.[4]

Readers attracted to a book organized by such an imaginative conceit could not fail to expect an equally ingenious treatment of Savannah's history. They were not disappointed. No dull inventory of facts and events, *Anchored Yesterdays* employed the immediacy of the present tense to propel the reader into the past. It appealed to its audience by providing much of what historians of the day often omitted: the vivid and the personal, the quaint and the bizarre, the broad suggestion and the telling detail—in a word, as the book's perfectly chosen epigraph from G. K. Chesterton put it, the "picturesque," which accommodated "a perfectly natural instinct . . . for what is memorable."[5]

Consequently, there are mentions of a murderous whale that in 1787 swam into the Savannah River and sank Captain Higgins's pilot boat, along with news of another huge mammal, exhibited in 1819: "A living Elephant is now to be seen in Jefferson Street." William Stephens, president of the colony, describes the progress of the construction of Christ Church in 1746: "The roof of the Church is covered with shingles, but as to the sides and ends of it, it remains a skeleton." Earlier in 1742, Stephens's "Malcontent" son Thomas suffers before the House of Commons for his attacks on the founders of Georgia: he is "brought upon his Marrowbones to be Reprimanded from the Chair."[6]

Equally important, the authors' sense of humor pervades the book without undercutting its serious purpose. Anyone expecting a dry recounting of flavorless facts was in for a surprise. In fact, one reviewer of the first edition predicted that readers would "enjoy many a hearty laugh over the numerous whimsical and amusing extracts from forgotten documents of our early history."[7]

One key to the humor involved the selection of various extracts from primary sources, which were then deployed, sometimes with commentary, sometimes without. In the authors' leave-taking of Oglethorpe, to whom they accord a balanced and perceptive summation, they also mention without comment that,

when in Savannah, Oglethorpe "stayed at the house of the widow Overend," who appears to have sprung from the pages of Henry Fielding. Sometimes there is a mixture of quotation and commentary: "Suffering from the summer heat [royal governor Henry Ellis] had complained that the inhabitants of Savannah probably breathed 'a hotter air than any other people on the face of the earth.' A happy coincidence seems responsible for his later appointment as governor of Nova Scotia." At other times the quotations provide their own amusement. A 1783 advertisement for a performance of the play *The Fair Penitent* warns that "no gentleman will be admitted behind the Scenes on any pretence." Later, a minister writes his brother regarding another play season: "In the course of the year 1802 I had to encounter a detachment of his Satanic majesty's forces, called 'Stage players.' They sat themselves in direct opposition to the interest of our Master's kingdom in Savannah, and fortified a garrison not fifty yards from a post I occupied at that time, called the 'Baptist meeting-house.'"[8]

Adding to the book's texture and flavor, much of its text emerged verbatim from the primary sources of the period, carefully selected by the authors (and italicized by them for emphasis) to provide the voices of participants in or observers of the book's events. "In beginning our book," Laura Palmer Bell recalled, "the plan was most successfully decided for us by Chesterton, who said history is 'giving a true picture instead of a false picture, but there is not a shadow of a reason why a picture should not be picturesque.' So finding the everyday speech of the early records most picturesque to us, we decided to use verbatim quotations wherever possible." William Stephens, for example, "wrote in his Journal on August 15, 1741, 'During the late storm we are now informed the Beacon at Tybee fell flat all at once, which we had expected for some time.' In those few words we knew there had probably been a hurricane, possibly termites had been as busy as they are now, and certainly people then as now put off work even when they knew it should have been done."[9]

The authors also sought to present a comprehensive array of topics, including not only military and political subjects, but also social, religious, economic, and literary matters. And, not least among its virtues, *Anchored Yesterdays* was competitively priced and quickly read; at $1.50 and just 131 compelling pages, it could be purchased cheaply and easily read in one sitting.[10]

Various newspaper notices in Savannah and Atlanta described the book's authors as "well-known Savannah women," both of them "from among the best

known of Savannah's old families." Though these attributes of the authors did not guarantee the book's interest or quality, they contributed to both.[11]

Before the publication of *Anchored Yesterdays*, the local prominence of Elfrida De Renne Barrow and Laura Palmer Bell stemmed from their literary—not historical—interests. They had been founding members in 1920 of the Prosodists, a group of five Savannah women devoted to the study of poetry, inspired particularly by the contemporary trends surveyed in Harriet Monroe's 1917 anthology *The New Poetry*. They met every Monday afternoon in a member's home to read and critique each other's verse, and they soon began drawing to Savannah such nationally renowned speakers as Monroe herself.[12]

Monroe appeared in March 1921 at the Bandbox Theater of the Huntingdon Club, another of a profusion of organizations of Savannah women. Its members (including Elfrida Barrow) had broad literary interests that led them to name their club after Selina, Countess of Huntingdon, an eighteenth-century patron of Georgia learning. Clad in a Russian tunic, Harriet Monroe spoke feelingly of the responsibilities of those with cultural interests. She urged her listeners to adopt a form of literary activism and singled out for praise the Prosodists. From "just such groups," she said, "and through just such interests . . . some of the finest movements in art develop."[13]

Later, reflecting on her visit to Savannah in a *Poetry* editorial, Monroe warned that Savannah might be "tempted to sit dreaming over her past, to linger in the two old moss-hung graveyards [Bonaventure and Laurel Grove] whose mournful beauty is a wonder-story all over the world. . . . The problem [was] to make the local loyalties generously productive and creative instead of narrowly exclusive and prejudicial, to sweep away hindrances between the imaginative energy of elect souls and the adequate expression of the energy in the arts and in life. The energy [was] there."[14]

While Monroe's praise (and her challenge) fueled the energy of Barrow's and Bell's circle, harsh criticism was already working to redouble it. H. L. Mencken's anti-Southern diatribes—notably his 1920 essay "The Sahara of the Bozart"—prodded the literati of the old Confederacy to respond to Mencken's charges of their region's intellectual aridity. In 1920 Charleston saw the organization of the Poetry Society of South Carolina, which would publish its own literary magazine and claim both Barrow and Bell as "non-resident members." Ad-

ditionally, Barrow was among those poets of the region whose verse was published (hers for the first time) in 1922's "Southern number" of *Poetry*. Spearheaded by the poetry society's DuBose Heyward and Hervey Allen, this special issue of Monroe's magazine was seen as a forceful answer to Mencken.[15]

Soon even the *New York Times*, in a January 1923 editorial entitled "Southern Culture," noticed what was termed a southern "literary and artistic renaissance." The Prosodists were particularly commended for their "intelligent activity and influence." Continuing, the editorial asserted, "These people are not dabblers and poetasters. They are producing high and serious work, much of it of undeniable beauty and felicity." In general, the *Times* highly praised "the new cultural movement in the South" (of which *Anchored Yesterdays* was to be a conspicuous product), and by 1925 H. L. Mencken himself would place the "revival of the South" among the "most significant phenomena" of modern American literature.[16]

In the meantime, the Prosodists had additional plans for expanding the movement the *Times* commended. Though another group had invited the distinguished poet Edwin Markham to visit Savannah in late February 1923, the Prosodists quickly commandeered him for their cause. Elfrida Barrow, Laura Bell, and their circle felt the time had arrived for a poetry society to be established in Georgia. With Markham, they had in Savannah not only the "unofficial poet laureate of America," but also the honorary president of the New York Poetry Society, the first such organization formed in the United States.

Entirely sympathetic to the Prosodists' goals, Markham inspired and energized a crowd of over one hundred people on the evening of February 20, 1923. This large gathering had met at short notice in the Georgia Historical Society's Hodgson Hall following an invitation for "all those interested in the study of poetry and literature" to assemble there. The Poetry Society of Georgia was organized that evening, with the "patriarchal" Markham consenting to be the society's honorary president and charter members Elfrida Barrow and Laura Bell among the slate of officers.[17]

Barrow and Bell thereafter devoted much of their time to the Poetry Society. Bell designed the society's seal, a precursor of the *Anchored Yesterdays* ship: "a frail little craft on a perilous sea sailing under the benison of a new moon." Both women's poems appeared in the society's publications over the next several de-

cades, as well as in other journals and anthologies. Though Barrow reached more of a national audience, Bell won more of the society's annual awards, drawing the praise of such esteemed judges as Louis Untermeyer and Conrad Aiken. The two friends would always think of themselves as poets, not as historians, and their gravestones would bear lines of their own verse.[18]

For the two poets 1923 proved a wondrous year, with the local press frequently printing news about the activities of the newborn Poetry Society of Georgia, which was increasingly a magnet for nationally known speakers. And this was also the year in which they released *Anchored Yesterdays*, another product of the intellectual ferment of their time and place. Their love of poetry contributed vitally to the book; many admirers of *Anchored Yesterdays* recognized the authors' immersion in verse as the major source of what has been described as the book's "literary flavor."[19]

Since Savannah and its first century of history are the subject of *Anchored Yesterdays*, an essential aspect of the book arose from its authors' varied connections to the port city. Laura Palmer Bell had a longer and more intimate relationship with the book's subject. Born in 1885 in Savannah, she received an education in one of the town's several small private schools. She knew from her earliest years, for instance, to expect the sea breeze to sweep in from the southeast.[20]

The childhood home of Laura Knapp Palmer stood very near the northwest corner of Bull and Jones streets, an intersection of pronounced historical import in Savannah lore. Facing each other diagonally across the Bull-Jones intersection stood the massive houses of Israel K. Tefft and Alexander A. Smets, inseparable friends and neighbors who had lived there until the 1860s and amassed extensive libraries of books and manuscripts, many pertaining to Georgia history. Nearby rose the Palmer home, three brick stories over a raised basement, built in 1857 for a related family, the Knapps, apparently by prominent architect John S. Norris. Flanked by gardens during Laura Palmer's childhood, the residence boasted an elegant neoclassical portico; the interior included a high stairwell illuminated by a "colored glass sky-light" and ceilings decorated with ornamental plasterwork.[21]

This large house was a necessity. When Laura was born there, it was the house of her grandparents, Herbert Armin Palmer and his wife Laura Cornelia (née Winkler), along with their children (including their son Armin Butler

Palmer, Laura's father, and his wife, born Lillie Carter Caldwell) and several grandchildren.[22]

Most vivid in Laura's reminiscence was the Palmer garden, her "grandmother's delight and constant care." A "fairly elaborate parterre," it lay along the east side of the home, with "paths of hard beaten black sand" and "beds finished with scalloped tile." Two large live oaks shaded part of the area, with the more sunlit beds full of bush roses. Numerous other flowers and shrubs grew there, including hibiscus, azaleas, and camellias.[23]

Another of Laura's memories of late-nineteenth-century Savannah was of the town's broad, sandy streets—"so wide that there were irregular green oases in the middle, marking the areas that horse drawn vehicles never encroached upon," and so deep with sand that she would never forget "the pull of a tired horse and the drag of the wheels as cascades of sand poured ceaselessly from the wheel rims." By the time *Anchored Yesterdays* was published, she had regretfully seen the popularity of automobiles lead to the paving over of gardens, as well as to the demolition of historic structures to create thoroughfares, filling stations, and parking lots, a process that would only worsen with time.[24]

In 1910 Laura married Malcolm Bell, and before long they had begun raising a family at 108 East Bolton Street, a three-storied frame Victorian structure built near the turn of the century. Although Malcolm Bell managed an electrical contracting firm at the time his wife co-wrote *Anchored Yesterdays*, he would later and until his retirement be a prominent and notably civic-minded Savannah newspaper official.[25]

The Bells' home stood only a few doors from Drayton Street, which formed the eastern border of the vast expanse of Forsyth Park, with its massive Confederate memorial a conspicuous landmark. To the north glistened a striking cast-iron fountain and across the park Hodgson Hall, packed with its wealth of Georgia historical materials, dominated the corner of Gaston and Whitaker.[26]

Several blocks farther north on Bull Street was Chippewa Square, in which stood Daniel Chester French's heroic statue of General James Oglethorpe, sword in hand. Since 1917 Dr. and Mrs. Craig Barrow had lived at 17 West McDonough Street, overlooking the square from the southwestern trust lot. The original antebellum house had twice been renovated and expanded. It made a spacious and elegant center of activity for the several organizations to which Elfrida Barrow belonged.[27]

Though both she and Laura Bell came from old Savannah families, no family in Savannah could claim to be older than Elfrida Barrow's: her great-great-great-grandfather Noble Jones had come to Savannah with the first group of Georgia colonists in 1733, when the place was no more than a pine-covered river bluff. Nonetheless, Barrow, herself, had known little of either Savannah or her forebears during her early years.[28]

Her father, Wymberley Jones De Renne, had most recently been a Texas rancher when her mother, born Laura Camblos in Philadelphia, learned that she was once again expecting a child. The De Rennes' firstborn, a son, had died in infancy and was buried on their now-abandoned ranch. Though the couple returned to Philadelphia for Elfrida's birth in January 1884, they soon sailed to Biarritz, on the French Atlantic coast, and there Elfrida received much of her early education. Consequently, she would throughout her life speak French as fluently as she spoke English.[29]

Even after her father decided in the early 1890s to return to Wormsloe, the family's ancestral estate near Savannah, Elfrida was seldom in Georgia. While De Renne transformed Wormsloe's vast Greek Revival house into a Victorian showplace, Elfrida remained in France. There she helped care for her younger siblings, Audrey and Wymberley, a task that she continued to perform after the family returned permanently to America. Half the year was usually spent in the North, away from Savannah's sultry climate, and soon Elfrida was spending most of her year at a Fifth Avenue boarding school in New York City. But once Elfrida was introduced to Wormsloe and Savannah, these places never strayed far from her mind, and her marriage in January 1906 to Dr. Craig Barrow at Wormsloe finally brought her to the Georgia coast for good.[30]

By the time Elfrida married, her father had made remarkable progress in gathering at his estate a matchless library of published and manuscript sources on the history of Georgia. Having outgrown the shelves in the house at Wormsloe, this library was moved in 1908 into a fireproof classical building nearby.[31]

When Elfrida Barrow and Laura Bell decided to collaborate on a publication, it could have taken a variety of forms. That it became a historical work must have been due in great part to the existence and easy accessibility of such an incomparable trove of books and manuscripts. The De Renne Georgia Library was the major source for materials for *Anchored Yesterdays*, and of the four in-

dividuals whom the authors thanked in print for help with their book, three had notable ties to the Wormsloe library.[32]

Certainly for Elfrida Barrow, the library represented most conspicuously her beloved father's life work (and his legacy to posterity after his death in 1916), and was probably a major inspiration for the book. On his deathbed, her father had received a solemn promise from her and her siblings that they would work to have his library appropriately cataloged, a process that was not completed until 1931. The 1923 book may have been an earnest of that promise. In any case, it is not surprising that the first numbered copy of *Anchored Yesterdays*, signed by both authors, was presented to the De Renne Georgia Library.[33]

Barrow's work in the library also seems to have reminded her of the legacy of her Georgia ancestors, who, as she later commented, were for many years "chronic strangers" to her. In large part the research on *Anchored Yesterdays* introduced her to these heretofore shadowy figures. Barrow's studies in her father's library made these ancestors more real to her, and the first three generations of her paternal line—Noble Jones, Noble Wimberly Jones, and George Jones—played important roles in the book, just as they had in history.[34]

Barrow and Bell were apparently also led to produce this particular book during the year they did because of the approach, a decade distant, of Georgia's bicentennial. The book, covering as it did Georgia's first century up to the celebration of the state's centennial, served as a sort of fanfare to the coming festivities.[35]

As a practical matter, *Anchored Yesterdays* (though completed by August 1923) was not scheduled to appear until December, so that it would be "ready for sale in time for the Christmas trade." Since the book was not sold by subscription—as was often the case with such locally produced publications—but through sales in stores, it was imperative that it reach the shelves in time for the gift-buying season, which it did.[36]

In preparing their text, Barrow and Bell had little in the way of outside assistance. Of the four individuals listed in the authors' acknowledgements, Anne Wallis Brumby appears to have been the only other person to participate actively in the preparation of the manuscript. Eight years the authors' senior, Brumby lived in Athens, the birthplace of Dr. Craig Barrow, and was among the Barrows' many friends and relatives in the university town. She and her sister Mary Harris, neither of whom ever married, lived in the oldest house in Ath-

ens—also, as it happened, the residence in which Dr. Barrow's maternal grandmother, Elizabeth Church (daughter of the University of Georgia's president, Alonzo Church), had spent some of her childhood years.[37]

At the time of the preparation of *Anchored Yesterdays*, Anne Brumby served on the faculty of Athens's famed Lucy Cobb Institute, and she was soon to become Dean of Women at the University of Georgia, of which she had been one of the first female graduates. Brumby's historical and literary interests matched those of Barrow and Bell, who thanked her "for her generous assistance in part of the compilation."[38]

Each of the other three individuals the authors thanked in print were connected in one way or another to the De Renne Georgia Library. One was Professor Robert Preston Brooks of Athens, who had been the De Renne Professor of Georgia History for several years and had done much research in the library at Wormsloe. The authors thanked him "for important and acceptable suggestions." They acknowledged, as well, Elfrida Barrow's brother, Wymberley Wormsloe De Renne, for "liberal access" to the Wormsloe library.[39]

Perhaps most important, the authors also thanked Leonard L. Mackall, who presumably was responsible for helping the two to navigate within the imperfectly cataloged sea of books and manuscripts that the De Renne library contained. Thanks to him "for valuable advice . . . , and for bibliographical information" no doubt covers a great deal of territory. No man alive knew more of the library's contents, for the scholarly bachelor had been the library's first and only librarian. He had also been intimately involved in the initial work on the forthcoming 1931 catalog, which would be ably introduced by him with a comprehensive history of the library and its treasures.[40]

The sources listed in the authors' bibliography were standard texts, all of which were found in the De Renne library at Wormsloe. The bibliography contained both general histories of Georgia and specific histories of Savannah, although during much of the period covered by *Anchored Yesterdays* state and Savannah history were essentially one and the same.[41]

Of the earlier state histories, those of Hugh McCall and William Bacon Stevens were Barrow's and Bell's main sources. Though both books had been published in the nineteenth century, neither author carried Georgia's story past the late 1700s, and were thus well within the *Anchored Yesterdays* timeframe. McCall's book also had the "virtue" of containing huge chunks of text copied

from an earlier eighteenth-century history of Georgia, and the modern reprint of his book employed by Barrow and Bell had the added advantage of having each page headed with the year under discussion.[42]

The most recent Georgia history Barrow and Bell used was Professor Brooks's synthesis, published in 1913, which had been prepared for use in Georgia's public schools. It also had been researched at the De Renne library, which had provided some of its illustrations.[43]

Published exemplars for *Anchored Yesterdays* did not exist. True, decades earlier two Savannah women had prepared *Historic and Picturesque Savannah* (1889), with Adelaide Wilson providing the text and Georgia Weymouth contributing drawings to be used among the illustrations. But their production was more a guidebook than a history. And Colonel Charles C. Jones's lengthy, ornate, and discursive history of Savannah published in 1890 was quite dissimilar to Barrow's and Bell's book.[44]

Closer to *Anchored Yesterdays*, in form at least, were two titles from around the turn of the century, Thomas Gamble's *History of the City Government of Savannah* (1901) and A. E. Sholes's *Chronological History of Savannah* (1900). Both of these, however, were the type of straightforward factual recounting that Barrow's and Bell's book emphatically was not, though each (particularly the Sholes chronology, which covered 1733–1833 in thirty pages) probably helped in outlining the later work. Gamble's chronological structure was particularly dense with facts. No doubt it was the source of a necessary, though relatively unappealing, part of *Anchored Yesterdays*: the frequent notice of turnovers in the Savannah mayor's office. The authors found it impossible to omit this class of fact and difficult to invest it with much interest. But the limited presence of such data served to remind the reader by contrast of how engaging the rest of the book was.[45]

Though some of the primary sources quoted in *Anchored Yesterdays* were to be found embedded verbatim in such histories as McCall's, Barrow and Bell did extensive research into original materials. They made excellent use of such sources as William Stephens's and the Reverend John Wesley's eighteenth-century journals; a compendious letter of royal governor Sir James Wright, written in 1761 and found in manuscript in the De Renne library; printed colonial records, drafted in both Georgia and England; period pamphlets, polemical and otherwise; and plans and maps of the years surveyed, including the two that

the authors chose to represent Savannah near the beginning and end of its ten watches. These are the famous 1734 bird's-eye view of the growing town on its bluff, attributed to Peter Gordon, and Isadore Stouf's much more complex "Plan of the City & Harbor of Savannah" (1818). The two images, both complete with sailing vessels plying the Savannah River, were attractively reproduced inside the book's front and back covers, in appropriate chronological order.[46]

Another vital aspect of the primary research was the use of early periodicals and newspapers, of which the De Renne library held an extensive collection. Of *The Gentleman's Magazine*, an eighteenth-century periodical published in London, there were seventeen volumes covering various years from 1732 to 1790, with some Georgia coverage throughout. And there was the *Georgia Gazette* (1763–1770), the colony's oldest newspaper, carefully photoduplicated and conveniently bound in seven durable volumes. Numerous later Georgia journals and newspapers could be found in the library's cases, and Barrow and Bell discovered many apt quotations within them.[47]

In presenting their book to the public in late 1923, the authors distributed a flyer, illustrated with Laura Bell's sketch of the lighthouse at Tybee Island, and including an order form, as well the authors' own partial assessment of their work. One of the blurbs read:

> Quotations from contemporary accounts with their quaint phraseology bring to this book a romantic atmosphere which makes those almost forgotten days as alive and vivid as yesterday itself, while concisely stated facts of historical value justify its ranking as a short and practical reference book of authoritative Georgia history.[48]

All of the authors' work resulted in a book that was received with appreciation and acclaim in Savannah by readers and critics alike. The *Savannah Evening Press* called the book "a charming looking little volume, attractively arranged" and "beyond the shadow of a doubt a valuable historical document . . . whose value cannot be overestimated. . . . when you put the little book down you feel that indeed you have lived again those pioneer days."[49]

More attuned to the cultural burgeoning to which *Anchored Yesterdays* belonged, the *Savannah Morning News* proclaimed that the book would "do its part toward establishing Savannah's claim not only as the seat of the colony, from which the culture of the state developed, but as a center of art and literature." Some of that local pride extended to the fact that the book "issued from the

press of the Review Publishing and Printing Company" of Savannah and was thus "truly a Savannah product and one which may be cherished, for the printing and make-up suit the contents and style admirably." Such a book, the reviewer asserted, would have "permanent value to students of history, but even more value and charm to lovers of literature, for it is a charming bit of literary workmanship, and its physical form is perfect."[50]

Praise came from beyond Savannah as well, even from Atlanta, which some among Savannah's social and intellectual elite viewed as a sort of unrefined, mercenary country cousin of Georgia's oldest city. Writing in the *Atlanta Constitution* (which also published portraits of the book's authors), James A. Hollomon called the book, despite its brevity, "as complete in the statement of every essential fact in Georgia's evolution . . . as that of any historian who has devoted volumes to the undertaking." While drawn to the book's picturesque, romantic, and humorous elements, Hollomon also recognized that the authors had not omitted the hardships, epidemics, wars, and disasters that were part of Savannah's history: "The fact is," he wrote, "in all seriousness, *Anchored Yesterdays* is a romance and also a tragedy."[51]

Professor Robert Preston Brooks reviewed *Anchored Yesterdays* for the *Georgia Historical Quarterly*. He found "ample internal evidence of a thorough examination of sources, as well as of the more important monographic literature." He appreciated the authors' bibliography, "giving a full list of authorities," as well as their "excellent index." As for the book as an object, it was "a beautiful example of the printer's art, well printed on excellent paper, and almost wholly free from typographical errors."[52]

Brooks's discovery of a couple of minor errors in the text (both from the 1740s) suggests that reading the manuscript prior to publication was not one of his contributions to the authors' work. He rightly pointed out that some sources suggest that the number given of 5,000 Spaniards at the Battle of Bloody Marsh was much too high. The number actually better matches the size of the entire Spanish force during its invasion of Georgia in 1742. The authors, however, did use a source that gave the high number, and they apparently considered that sufficient evidence. The other assertion contested by Brooks, that "commerce" began in Savannah in 1749, is vague at best. But Barrow's and Bell's contention that foreign trade began that year was correct, insofar as the sources marked it as the year that a private establishment, Harris & Habersham, first sent a ship

to England (in contrast to vessels sent by the Trustees). In any case, the authors appear not to have agreed with Brooks that these were errors, since both were repeated in the 1933 compilation *Georgia: A Pageant of Years*, of which Elfrida Barrow was a co-author and for which *Anchored Yesterdays* served as a model.[53]

In addition to the accolades of reviewers, Barrow and Bell received welcome praise from John Bennett in Charleston. Well-known as an author and artist (whose work was loved by the Barrow and Bell children), Bennett was one of the pair's allies in the Poetry Society of South Carolina and would be a longtime supporter of Georgia's poetry society as well.[54]

As an artist, Bennett was taken with "the attractiveness of the book as a book," and he found it "charming, and well-done." Mrs. Bell's frigate he called "a joy . . . something to look at and to dream over." As a history-lover, he was tantalized: "When I laid down *Anchored Yesterdays*, it was with a desire very sharp and keen to turn immediately to . . . all the source-material on my shelves, and re-read the history of Georgia. . . . If the Savannahians who read your book don't want at once to know more of the history of their city, they have supine and indifferent minds, and no wholesome relish for the actual history of their home. . . . it is a fine story, and its truth more picturesque than the fallacies so long cherished by the unenquiring herd. Your poetical, or was it romantic, fancy, turning historic periods to watches, truly adds just the suggestion of romance which turns the fact to an intrigue of fantasy. I'll label it a lure."[55]

Anchored Yesterdays, then, succeeded on many levels for Elfrida Barrow and Laura Bell, and it seemed appropriate that such a productive collaboration would have a sequel. Consequently, the authors' friends and admirers must have been pleased to see a 1928 announcement of a forthcoming book from the authors of *Anchored Yesterdays* to be entitled *The Old Squares of Savannah*. Sadly, the book never came to be. And, though the two continued to collaborate in other ways for the rest of their lives, they would never again co-author a book together.[56]

Although the Poetry Society of Georgia claimed much of their time, the two began in 1934 to channel much of their historical interest into the newly formed Savannah Historical Research Association (SHRA). Some of their preparatory research on Savannah's squares appeared in papers read at the association's meetings. Additionally, Laura Palmer Bell's SHRA paper titled "The Vanishing

Gardens of Savannah" appeared in 1944 in a special issue that the *Georgia Historical Quarterly* devoted to the work of the organization. Elfrida Barrow, on the other hand, participated through the Georgia Society of Colonial Dames in the publication during the 1930s and 1940s of several books related to Savannah and coastal Georgia history.[57]

A major link between the two women, their living near each other in Savannah, was broken in 1938 when Elfrida Barrow and her husband moved to Wormsloe. But additional links were forged between Barrow and Bell during the 1930s. In 1936 Malcolm Bell Jr. married the Barrows' daughter Muriel, and two years later Craig Barrow Jr. married Laura Palmer Bell, her mother's namesake.[58]

After her husband's death in 1945, Elfrida Barrow, continued to live at Wormsloe until her death and burial there in 1970. An absorbing preoccupation of her last quarter century would be the Wormsloe Foundation, which she would charter in 1951. The foundation was (and continues to be) devoted to historical preservation, as well as to the publication of books, mainly primary sources from the era covered by *Anchored Yesterdays*. Over the years the Foundation's Board of Trustees would include children and grandchildren of both Elfrida Barrow and Laura Bell.[59]

As had the Barrows, Laura Bell and her husband left Savannah. They lived for many years east of town at Turner's Rock, a marsh-flanked, oak-covered arm of land that projects from Whitemarsh Island into the Wilmington River. The Bells' house there, of Savannah gray brick, was surrounded by azaleas. Malcolm Bell, an inveterate and inspired gardener, also grew prize camellias there, reminiscent of those in the Palmer garden on Jones Street, and took pleasure in giving away their blooms.[60]

Laura Bell continued to live at Turner's Rock for several years after her husband's death in 1962. While there she created a stir in the Savannah press and in historical circles with another article for the *Georgia Historical Quarterly*. Published in 1964, just four years before Bell's death, this article comprehensively surveyed all the earlier ideas regarding Oglethorpe's source for his distinctive Savannah town plan and revealed Bell's own intriguing hypothesis: Oglethorpe's Savannah was modeled after a map of Peking, China, that bears a striking resemblance to Savannah's grid of streets and squares.[61]

In September 1956 Elfrida Barrow and Laura Bell were surprised to see *An-*

chored Yesterdays republished. Though this new edition gave testimony of their book's continued vitality, worth, and popularity after more than twenty years, it emerged without the authors' prior knowledge. The Little House, a gift and book shop established by the authors in the 1920s, had by this time changed ownership, and the new owner, Isabelle Harrison, had arranged to have the book re-issued, in entirely new format, as the first book to be printed by the Ashantilly Press of Darien, Georgia. Though this was not an entirely pleasant surprise, Barrow and Bell came to admire the new edition.[62]

Undeniably a handsome piece of work, accurately described as "a little classic in typography," the Ashantilly version was essentially an *édition de luxe* of the original. Its creator, William Greaner Haynes Jr. remained justifiably proud of his edition when interviewed in 1997, by which time his private press had won many awards, including one for *Anchored Yesterdays*. Laboring for nearly a year, he produced the 1956 edition with first-rate materials, hand-set typefaces, and attractive ornaments (some created especially for the Ashantilly edition). The second edition sold at the quite reasonable price of $3.50. Apart from the book's sumptuous presentation, Haynes meticulously made some minor corrections to several of the bibliography citations and also improved the index. Consequently, some enthusiasts of the book prefer the second to the original edition. Those who remain partial to the 1923 edition consider the 1956 version too elaborate, as well as less effective in illustrating the authors' nautical theme.[63]

That such matters could be deemed worthy of discussion in the year 2001 suggests that the sprightly craft launched in 1923 by two remarkable women remains afloat. A third edition has now arrived in port. Going aboard, a new generation will discover, as did previous ones, that it is richly laden.[64]

NOTES

1. *Savannah Evening Press*, December 22, 1923.

2. Elfrida De Renne Barrow and Laura Palmer Bell, *Anchored Yesterdays: The Log Book of Savannah's Voyage Across a Georgia Century* (Savannah, 1923). Hereafter cited as *Anchored Yesterdays*.

3. *Anchored Yesterdays*, [3], 19, 130–31; *Savannah Morning News*, December 16, 1923; Dean King et al., *A Sea of Words* (New York, 1997), 451–52.

4. *Anchored Yesterdays*, [11], [17], [37], [61], [109]; King et al., *A Sea of Words*, 110.

5. *Savannah Morning News*, December 16, 1923; *Anchored Yesterdays*, [5]. Indications are that

the authors finished their manuscript in the summer of 1923; consequently, their discovery of the Chesterton quote in a June issue of *The Illustrated London News* was quite auspicious. The full citation is G. K. Chesterton, "Our Notebook," *The Illustrated London News*, June 23, 1923, p. 1090.

6. *Anchored Yesterdays*, 81, 116, 40, 35.

7. Robert Preston Brooks, Review of *Anchored Yesterdays*, *Georgia Historical Quarterly* 8 (March 1924): 71. *Georgia Historical Quarterly* hereinafter cited as *GHQ*.

8. *Anchored Yesterdays*, 39, 51, 78, 97. Earlier in 1923 Barrow had effectively used an apparently unpromising primary source (the *Register of Deaths in the City of Savannah, October 29, 1803, to November 30, 1806*) in an article entitled "'Memento Mori,'" and in a later article she would similarly treat advertisements from the 1829 *Savannah Georgian*; see Elfrida De Renne Barrow, "'Memento Mori,'" *GHQ* 7 (June 1923): 166–73, and "On the Bay One Hundred Years Ago," *GHQ* 14 (March 1930): 1–16.

9. *Anchored Yesterdays*; Laura Palmer Bell, Typescript of Remarks on *Anchored Yesterdays*, February 12, 1957, courtesy of Malcolm Bell III. (This is a draft used by Bell in addressing the Georgia Historical Society during a "A Salute to Fine Printing in Georgia"; minor emendations have been silently made.)

10. *Savannah Evening Press*, December 22, 1923; *Atlanta Constitution*, December 30, 1923; "Announcing A Historical Publication" [*Anchored Yesterdays* advertising flyer, 1923], Wormsloe Collection, Hargrett Rare Book and Manuscript Library, University of Georgia Libraries, Athens, Georgia. Location hereinafter cited as Hargrett Library.

11. *Savannah Evening Press*, December 22, 1923; *Atlanta Constitution*, December 30, 1923.

12. Gerald Chan Sieg, *A Recollection: The Poetry Society of Georgia, 1923–1998* (Savannah, 1998), 20; Jane Judge, "Personal Impressions of Literary Persons Who have Visited Savannah from 1882 to the Present Day [1931]," 12–13, Savannah Historical Research Association Papers, Ms. 994, Georgia Historical Society, Savannah, Georgia. Hereinafter cited as Judge, "Personal Impressions." Georgia Historical Society hereinafter cited as GHS.

13. Judge, "Personal Impressions," 12–13; *Savannah Morning News*, March 10, 1921.

14. *Poetry: A Magazine of Verse* 18 (May 1921): 94.

15. Fred Hobson, *Mencken: A Life* (New York, 1994), 213–14; Frank Durham, "The Rise of DuBose Heyward and the Rise and Fall of the Poetry Society of South Carolina," *Mississippi Quarterly* 19 (Spring 1966): 67–69; *Year Book of the Poetry Society of South Carolina* (Charleston, 1925), 62; *Poetry: A Magazine of Verse* 20 (April 1922): 19.

16. *New York Times*, January 28, 1923, p. 6-E; *Year Book of the Poetry Society of South Carolina* (Charleston, 1925), 9.

17. Judge, "Personal Impressions," 14–15; Minutes of Meeting, February 20, 1923, Poetry Society of Georgia Papers, Ms. 1215, GHS.

18. Katharine H. Strong, "The Poetry Society of Georgia," *Georgia Review* 8 (Summer 1954): 30; Poetry Society of Georgia, *Yearbooks*, 1924–1970; Poetry Society of Georgia, *Twenty-fifth Anniversary: The Poetry Society of Georgia, 1923–1948* (Athens, 1949), 1–15; William Harris Bragg, *De Renne: Three Generations of a Georgia Family* (Athens, 1999), 364–69.

Two early anthologies that included poems by Barrow and Bell were the Poetry Society of Georgia, *Anthology of Verse* (Savannah, 1929) and Thornwell Jacobs, ed., *The Oglethorpe Book of Georgia*

Verse (Oglethorpe University, Ga., 1930). Each anthology includes the lines of verse that embellish the authors' gravestones (in the Barrow Family Cemetery, Wormsloe [Private], and Bonaventure Cemetery, Savannah, respectively). From Elfrida De Renne Barrow's "Garden's End": "Perhaps / Beyond that undeciphered bend / Waits another garden's end— / Another gate / Swings open to another spring. / This is an estimate that blinds my reckoning." From Laura Palmer Bell's "The Wind": ". . . Eternal calm / When life is done, / For the wind and the breath / Of life are one."

19. Newspaper Clippings for 1923, Poetry Society of Georgia Papers, Ms. 1215, GHS; *Savannah Morning News*, October 31, 1923 (an article previewing the book's December publication).

20. Laura Palmer Bell, "The Vanishing Gardens of Savannah," *GHQ* 28 (September 1944): 199.

The house where Laura Palmer was born and spent her childhood survives but has been subdivided into apartments. Hugh S. Golson of Savannah generously supplied some of this essay's information regarding Laura Palmer Bell, his great-aunt, and Malcolm Bell III and Elfrida Barrow Moore likewise provided materials on their grandmothers.

21. Bell, "Vanishing Gardens," 199, 200–201; Bragg, *De Renne*, 20–21, 457n.13; Mary Lane Morrison, *John S. Norris, Architect in Savannah, 1846–1860* (Savannah, Ga., 1980), 44–45, 47.

The spacious garden to the west of the Palmer house, "one of the largest gardens in Savannah," belonged to the Tison family, who lived in the house now numbered 20 West Jones Street. A "pair of red brick tenement houses," closely abutting the Palmer house, has occupied most of the site of the Tison garden since 1891 (Bell, "Vanishing Gardens," 201; Mary L. Morrison, ed., *Historic Savannah* [Savannah, 1979], 124–25).

22. Bell, "Vanishing Gardens," 201, 201n.4; Horace Wilbur Palmer, comp., *The Palmer Family in America*, 3 vols. (Neshanic, N.J., and Somersworth, N.H., 1966–1973), 3: 197.

23. Bell, "Vanishing Gardens," 200, 203–4.

24. Bell, "Vanishing Gardens," 196, 200, 202; Mills Lane, *Savannah Revisited: History and Architecture* (Savannah, 1994), 214.

25. Undated clipping, Malcolm Bell, Jr., Collection, Ms. 1283, GHS; *Savannah City Directory, 1923*, 234; Morrison, ed., *Historic Savannah*, 268; *Savannah Morning News*, October 3, 1962. Laura Palmer Bell had political as well as literary interests and in 1920 was among the first group of women to register to vote in Chatham County "by a coup d'etat on the part of suffrage leaders" (*Savannah Morning News*, August 28, 1920).

26. Morrison, ed., *Historic Savannah*, xxx–xxxi, 222–23; William Harden, *Recollections of a Long and Satisfactory Life* (Savannah, 1934), 80, 147–78; Robert M. Hitch, "Modern Savannah," *GHQ* 13 (September 1929): 339–40.

27. *Savannah Morning News*, June 18, 1912; Savannah Ward Books (Lots 37 and 38, Brown Ward), GHS.

28. *Register of the Georgia Society of Colonial Dames of America* (Baltimore, 1937), 84; Elfrida De Renne Barrow to E. Merton Coulter, [1929], E. Merton Coulter Papers, Hargrett Library.

29. Bragg, *De Renne*, 214, 218–19, [359].

30. Ibid., [223]–26, 230, 286–87, 360.

Dr. Barrow, for much of his career the chief surgeon of the Central of Georgia Railway Company and founder of its Savannah hospital, was also an early proponent of preventive medicine (*Savannah Morning News*, September 1, 1945).

31. Bragg, *De Renne*, 283–85.

32. *Anchored Yesterdays*, [9].

33. Bragg, *De Renne*, 310–11, 320–23, 337, 341; *Anchored Yesterdays* [Wymberley Jones De Renne Georgia Library copy, Call Number DeR3/1923/B3], p. [7], Hargrett Library.

34. Bragg, *De Renne*, 375, 381; *Anchored Yesterdays*, 40, 44, 49, 58, 60, 64, 65, 67, 70, 103, 107, 111, 125, 129.

35. *Savannah Morning News*, December 16, 1923; *Savannah Evening Press*, December 22, 1923.

36. John Bennett to Elfrida De Renne Barrow, August 19, 1923, John Bennett Papers, South Carolina Historical Society, Charleston, South Carolina; *Savannah Morning News*, October 31, 1923.

37. *Athens Banner-Herald*, February 23, 1964; *Athens Advertiser*, March 4, 1964; "Resolution on Miss Anne Wallis Brumby," Vertical Files, Georgia Room, Hargrett Library; Lucian Lamar Knight, *A Standard History of Georgia and Georgians*, 6 vols. (New York, 1917), 6: 2818.

38. *Athens Banner-Herald*, February 23, 1964; *Anchored Yesterdays*, [9].

39. Bragg, *De Renne*, 304–5; *Anchored Yesterdays*, [9].

40. *Anchored Yesterdays*, [9]; Bragg, *De Renne*, 308–10, 320–22, 339.

41. *Anchored Yesterdays*, [133]–[35]; Azalea Clizbee, comp., *Catalogue of the Wymberley Jones De Renne Georgia Library*, 3 vols. (Wormsloe, Ga., 1931).

42. Hugh McCall, *The History of Georgia* (2 vols., 1811–1816; 1 vol. reprint, Atlanta, Ga., 1909); William Bacon Stevens, *A History of Georgia*, 2 vols. (New York, 1847; Philadelphia, 1859); Bragg, *De Renne*, 44–45, 46.

43. Robert Preston Brooks, *History of Georgia* (Atlanta, 1913), iv.

44. Adelaide Wilson, *Historic and Picturesque Savannah* (Boston, 1889); Charles C. Jones Jr. et al., *History of Savannah, Ga. From Its Settlement to the Close of the Eighteenth Century by Charles C. Jones, Jr. From the Close of the Eighteenth Century by O. F. Vedder and Frank Weldon* (Syracuse, 1890).

45. Thomas Gamble, *A History of the City Government of Savannah, Ga., from 1790 to 1901* [Savannah, 1901]; A. E. Sholes, *Chronological History of Savannah* (Savannah, 1900).

46. *Anchored Yesterdays*, passim.

47. Azalea Clizbee, comp., *Catalogue of the Wymberley Jones De Renne Georgia Library*, 3 vols. (Wormsloe, Ga. 1931), 1: 17, 3: 1167.

48. "Announcing A Historical Publication" [*Anchored Yesterdays* advertising flyer, 1923], Wormsloe Collection, Hargrett Library.

49. *Savannah Evening Press*, December 22, 1923.

50. *Savannah Morning News*, December 16, 1923.

51. *Atlanta Constitution*, December 30, 1923.

52. Robert Preston Brooks, Review of *Anchored Yesterdays*, *GHQ* 8 (March 1924): 71, 73.

53. Ibid., 72; *Anchored Yesterdays*, 35, 41; Sholes, *Chronological History*, 47; Mary Savage Anderson, Elfrida De Renne Barrow, Elizabeth Mackay Screven, and Martha Gallaudet Waring, *Georgia: A Pageant of Years* (Richmond, Va., 1933), 27, 29; Bragg, *De Renne*, 381–82. *Georgia: A Pageant of Years* chronologically surveyed Georgia history from 1513 to 1933 and was published as a contribution to the Georgia Bicentennial by the Georgia Society of the Colonial Dames of America, of which all the authors were members.

54. Bragg, *De Renne*, 369; Laura Palmer Bell to John Bennett, 27 April 1925, John Bennett Papers, South Carolina Historical Society, Charleston, South Carolina.

55. John Bennett to Elfrida De Renne Barrow, March 8, 1924, John Bennett Papers, South Carolina Historical Society, Charleston, South Carolina.

56. *The Year Book of the Poetry Society of South Carolina* (Charleston, 1928), 55.

Anchored Yesterdays would nevertheless, in one sense, remain current for the remainder of its authors' lives. Barrow's and Bell's book figured prominently among the sources of the standard college text for Georgia history during most of the twentieth century. University of Georgia professor E. Merton Coulter, legendary "dean of Georgia historians" and a great admirer of the book, cited it in several chapters of his *A Short History of Georgia* (Chapel Hill, 1933), as well as in its 1945 and 1960 revisions, and kept it on his list of suggested books for his Georgia history course at the university.

57. "Officers and Members of the Savannah Historical Research Association, 1934–1944," *GHQ* 28 (September 1944): 225; "A Guide to Unpublished Papers in the Files of the Savannah Historical Research Association," ibid., 217; Laura Palmer Bell, "The Vanishing Gardens of Savannah," ibid., 196–208.

In keeping with her historical interests, Elfrida Barrow also served for a time as a curator of the Georgia Historical Society, as had her grandfather, father, and brother before her (*GHQ* 20 [March 1936]: 66; *GHQ* 26 [June 1942]: 196).

A list of Barrow's publications, both literary and historical, can be found in Bragg, *De Renne*, 427–32.

58. Bragg, *De Renne*, 370, 384.

59. Ibid., 386, 388, 396, 432–34, 560n.1; *Savannah Morning News*, October 2, 1970.

60. *Savannah Morning News*, October 3, 1962 and February 28, 1965.

Many years previously the Bells had moved from Bolton Street to a new home on Drayton Street.

61. *Savannah Morning News*, February 28, 1965; Laura Palmer Bell, "A New Theory on the Plan of Savannah," *GHQ* 43 (March 1964): 147–65; *Savannah Morning News*, January 4, 1968.

Laura Bell also published *The Widening Circle* (Savannah, 1934), a small book that unfolded into a genealogical chart comprised of concentric circles. *The Widening Circle*'s designer was Burnley Weaver (1898–1963) of the Gollifox Press of Biltmore, North Carolina.

62. Elfrida De Renne Barrow and Laura Palmer Bell, *Anchored Yesterdays: The Log Book of Savannah's Voyage Across a Georgia Century, in Ten Watches* (Savannah, 1956); Bragg, *De Renne*, 369; *Savannah Morning News*, September 9, 1956; Malcolm Bell III to the author, August 31, 2000.

Additional proof of *Anchored Yesterdays*'s continued worth and vitality can be seen at rare book dealers' websites. In February 2001 the original edition was listed at prices from $30 to $192.

63. *Savannah Morning News*, September 9, 1956; Susan Garrett Mason, "The Lord of Ashantilly," *Georgia Journal* 17 (May/June 1997): 22; *Anchored Yesterdays: The Log Book of Savannah's Voyage Across a Georgia Century, in Ten Watches* (Savannah, 1956). The views described in the text represent a small and unscientific survey of admirers of both editions.

64. *Savannah Evening Press*, December 22, 1923.

A LIST OF AUTHORITIES QUOTED.

The *"Sea Mark"* at the head of each Watch is adapted from a wash drawing by De Brahm entitled "VIEW OF TIBY LIGHTHOUSE at the Entrance of Savanna River. Georgia. Dec. 1764." Presented by him to King George III. and now in the British Museum.

De Brahm's duplicate, in the Wormsloe Library, is reproduced in the Georgia Historical Society Collections. Vol. VIII.

ANSWERS TO THE QUERIES sent by the Right Honorable the Lords of Trade, and received by me the first of October. 1761. *Ms. signed by James Wright, Governor of Georgia. (In the W. J. De Renne Collection, Wormsloe Library.)*

A BRIEF ACCOUNT of the Establishment of the Colony of Georgia under General James Oglethorpe, Feb. 1, 1733. Washington. 1835. Force's Tracts, Vol 1 No. 2. *A reprint of contemporary accounts.*

BROOKS, ROBERT PRESTON. History of Georgia, Boston etc. 1913.

THE CHARTER OF THE COLONY. *Quoted as printed in the Colonial Records. Vol. I.*

THE COLONIAL RECORDS OF THE STATE OF GEORGIA, Edited by Allen D. Candler. Atlanta 1904, etc.

EGMONT, JOHN, EARL OF. A Journal of the Proceedings of the Trustees for establishing the Colony of Georgia in America, Privately printed. Wormsloe 1886. [Cambridge, Mass.]

FRANKLIN, BENJAMIN. A Letter. *An original autograph ms. in the possession of Mrs. Craig Barrow, Savannah.*

GAMBLE, THOMAS. A History of the City Government of Savannah from 1790 to 1900 *(appended to Annual Report of Mayor of Savannah for 1900.)* [Savannah 1900.]

THE GENTLEMAN'S MAGAZINE. *(For July 1733, and March 1740.)* London.

GEORGIA HISTORICAL SOCIETY. COLLECTIONS.

GREENE, JOHN RICHARD. A Short History of the English People. New York 1895. *Edited By Mrs. J. R. Greene & Miss Kate Norgate.*

HOLCOMBE, HENRY. The First Fruits, a series of letters. Philadelphia 1812.

JONES, C. C., JR. History of Savannah, Ga. Syracuse. 1890. The Life and Services of Commodore Josiah Tattnall. Savannah, 1878.

LEVASSEUR, A. Lafayette in America, 1824-1825 Philadelphia. 1829.

MCCAIN, JAMES ROSS. Georgia as a Proprietary Province. Boston. 1917.

MCCALL, HUGH. The History of Georgia. 2 Vols. Savannah. 1812-1816. *Reprinted Atlanta 1909.*

NEWSPAPERS. The Georgia Gazette, The Columbian Museum and Savannah Advertiser, The Republican and Savannah Evening Ledger, The Georgian, The Savannah Gazette.

THE MINUTES OF THE COMMON COUNCIL of the Trustees for Establishing the Colony of Georgia in America. *Quoted as printed in the Colonial Records.*

MOORE, FRANCIS, A Voyage to Georgia. London. 1744. *Reprinted in the Georgia Historical Society Collections Vol. 1. 1840.*

PHILLIPS, ULRICH BONNELL. Georgia and States Rights. Washington 1902. *(Annual Report of the American Historical Association for 1901. Vol. 2)*

PULASKI VINDICATED From an Unsupported Charge, Inconsiderably or Malignantly introduced in Judge Johnson's Sketches of the Life and Correspondence of Nathaniel Greene. Baltimore. 1824. [PAUL BENTALOU.]

SHOLES, A. E. Chronological History of Savannah. Savannah. 1900.

SMITHSONIAN INSTITUTION. Annual Report for 1890, (Part II). *Report of the U. S. National Museum. Wash. 1890 contains:* "The Log of the Savannah." by J. E. Watkins.

STEPHENS, WILLIAM. A Journal of the Proceedings in Georgia to which is added A State of the Province of Georgia attested upon oath in the Court of Savannah, 3 Vols. London, 1742. *Reprinted in Colonial Records, Vol. 4, & Supplement.*

STEVENS, W. B. History of Georgia. 2 Vols. New York, Philadelphia 1847-1859.

TAILFER, (PAT.) ANDERSON, (HUGH M. A.) DOUGLAS. (DA) and Others. A True and Historical Narrative of the Colony of Georgia in America, etc. Charleston—1741. *Reprinted in Collections of Georgia Historical Society from Forces's Tracts.*

WASHINGTON, GEORGE. The Diary of George Washington, from 1789 to 1791 Edited by B. J. Lossing. New York. 1860.

WESLEY, JOHN. The Journal of the Rev. John Wesley, A. M. Edited by Nehemiah Curnock. London. [1909.]

WHITE, GEORGE. Statistics of the State of Georgia. Savannah. 1849.

WHITEFIELD, GEORGE. A Continuation of the Reverend Mr. Whitefield's Journal from his arrival at Savannah, to his return to London. London. 1739.

WILSON, ADELAIDE. Historic and Picturesque Savannah. Boston. 1889.

RECK, (P. G. F.) VON. An Extract of the Journals of Mr. Commissary Von Reck. London. 1734.

THE INDEX

Acadians, 49, 50.
Adams, John, 91, 92.
Adams, John Quincy, 124, 127.
Anderson, Hugh, 34.

Baldwin, Abraham, 79.
Berrien, John McPherson, 127.
Bethesda, 28, 29, 32, 33, 59, 82, 104, 129.
Bloody Marsh, 35.
Bolton, Robert, 55.
Bolzius, Rev. John Martin, 22, 41.
Bosomworth, Mary, 41.
Bosomworth, Rev. Thomas, 40, 41.
Bryan, Andrew, 82.
Bryan, Jonathan, 19, 49, 82.
Bull, William, 19.
Bulloch, Archibald, 64, 65, 67, 68, 69, 70.
Bulloch, William B., 105.
Burr, Aaron, 97.

Calhoun, Mr. (Sec. of War), 117.
Campbell, Col. Archibald, 71, 72.
Carlton, Sir Guy, 74.
Causton, Thomas, 27, 28, 29.
Change of Calendar, 45.
Charter granted to Trustees, 11, 12, 13.
Charter resigned by Trustees, 44.

Charlton, Robert M., 130.
Charlton, Judge T. U. P., 105, 112, 113, 118, 120.
Clay, Joseph, 66.
Constitutions, adoption of, 70, 83, 94.
Cotton, early mention, 33, first shipped, 64.
"Curse upon Savannah," 114, 115.

Daniell, William C., 124, 125, 126.
Davis, William, 104.
De Lyon, 22.
d'Estaing, Count, 72, 73.
Dolly, Quamino, 72.
Douglas, David, 34.
Dry culture of rice, 123, 126.

Egmont, John, Earl of (see Percival), 14, 30, 35.
Elbert, Samuel, 79, 82.
Ellis, Henry, 50, 51.
Ervine, John, 103.
Ewen, William, 66.

Federal Constitution adopted, 82.
Fires, 30, 33, 93, 118.
First newspaper, 55.
Floyd, Brig. Gen., 111.
Fowler, Mr., 101.
Franklin, Benjamin, 58, 60, 84.
Frink, Rev. Samuel, 59.
Fulton, Robert, 113.

Gaines, Gen., 117.
General Assembly of Georgia, first, 70.
George II., 11, 52.
George III., 52, 69, 77.
Gibbons, Thomas, 86, 91, 95, 96.
Gibbons, William, 66.
Glen, John, 94.
Golf Club, Savannah, 93, 106.
Goodwin, Mr., 93.
Gordon, Peter, 23.
Green, John H., 113.
Greene, Gen. Nathaniel, 73, 77, 80, 102, 125.
Grimes, John, 103.
Gronau, Israel Christian, 22.
Gwinnett, Button, 68, 70, 71.

Habersham, James, 39, 41, 55, 59, 67.
Habersham, Joseph, 66, 68, 87, 91.
Habersham, Richard W., 129.
Hall, Lyman, 67, 68, 77.
Hancock, John, 69.
Harney, John M., 114.
Harris, Charles, 101, 104.
Harris, Francis, 41, 44.
Herbert, Rev. Henry, 14.
Holcombe, Rev. Henry, 95, 96.
Hopkey, Sophia, 29.
Houstoun, John, 64, 65, 67, 68, 71, 78, 82.
Howard, Mr., 113.
Howe, Gen. Robert, 72.
Huntingdon, Countess of, 59.

Ingham, Rev. Benjamin, 27.

Jackson, Andrew, 112, 127.
Jackson, James, 74, 91, 92, 94, 103, 105.
Jackson, Joseph W., 126, 127.
Jasper, Sergeant, 73.
Jefferson, Thomas, 96.
Johnson, Eliza, 106.
Johnson, James, 55, 77.
Jones, George, 107, 111, 125, 129.
Jones, Noble, 40, 44, 49, 60, 64, 67.
Jones, Noble Wimberly, 58, 60, 65, 66, 67, 70, 103.
Jones, Thomas, 29.

Kollock, Lemuel, 103.

Lafayette, Gen., 124, 125, 126.
Lamb, George, 94.
Lumpkin, Governor, 129.
Lee, Lieut. Col. (Light Horse Harry), 74.
Lincoln, Gen. Benjamin, 72, 73.
Lloyd, Edwin, 80.

McAllister, Matthew, 94, 111, 131.
McCall, Capt. Hugh, 106, 113.
McIntosh, Lachlan, 68, 71, 73, 86.
McLeod, Rev. John, 24.
Mackay, Robert, 104.
Madison, James, 112.
Malatche, 40.
Malbone, Edward G., 104.

Malcontents, 34.
Masonry, 25, 30, 50, 95, 125.
Marshall, Rev. Abraham, 82.
Martin, Clement, 67.
Mendenhall, Thomas, 105.
Milledge, John, 66, 79.
Milledge, Richard, 43.
Minis, 22, 83.
Mitchell, David B., 96.
Monroe, James, 117.
Moore, Francis, 26.
More, Hannah, 79, 86.
Morgan, William, 86.
Morris, Robert, 71.
Morrison, James, 120, 123.
Mulryne, 102.
Murat, Achille, 126.
Musgrove, Mary, 19, 40.

Noel, John Y., 92, 102, 103.

Oglethorpe, James, 11, 12, 14, 19, 20, 23, 26, 29, 31, 32, 35, 39, 79, 80, 129, 130.
Owens, George W., 128.

Parker, Commodore, 71.
Parker, Henry, 44.
Peale, Raphaelle, 101.
Peale, Rembrant, 101, 102.
Percival, John, Viscount, (see Egmont).
Pickens, Gen., 74.
Pierce, Rev. Mr., 130.
Pitt, William, Earl of Chatham, 57.
Prevost, Lieut. Col. Mark, 71, 72, 73.

Prohibition of rum, 22, 24, 35, 41, 42.
Provincial Congress, 65, 66, 68.
Provost, Gen. Augustine, 71.
Pulaski, Count, 73, 125.

Raikes, Robert, 25.
Reck, Baron Von, 20.
Reynolds, Governor John, 49, 50.
Rogers, Capt. Moses, 115, 117.
Ross, Elizabeth, 71.
Ross, Col., 71.

Savannah incorporated as a city, 82.
Scarborough, William, 115, 117.
Scenauki, 23.
School for Dancing, 93.
Screven, Gen., 72.
Sheftall, 22, 43, 52, 84.
Siege of Savannah, 72, 73.
Silk Culture, 13, 20, 21, 23, 27, 44, 49, 51, 55, 56, 57.
Slavery, (negro), 11, 24, 30, 31, 35, 41, 43, 94.
Stephens, William (Sec. to the Trustees), 27, 28, 29, 30, 31, 32, 33, 34, 35, 39, 40, 42, 44, 49, 80.
Stephens, Thomas, 34, 35.
Stephens, William, 81, 91, 92, 95.
Stirk, Samuel, 70, 82.

Tailfer, Dr. Patrick, 32, 34.

Tattnall, I. (ex-Gov. of Ga.), Josiah, 102.
Tattnall, II. (later Commodore), Josiah, 106.
Telfair, Edward, 66, 80, 82, 85.
Theatres, 78, 93, 96, 97, 115, 128.
Timothy, Lewis, 25.
Tomochichi, 19, 23, 31.
Tondee, Peter, 43, 64, 66.
Toonahowi, 23.
Treaties with Indians, 21, 31, 50, 127.
Treutlen, John Adams, 70.
Troup, Gov., 125, 127.
Trustees, names of important, 14.
Trustees' Garden, 26, 27, 32.
Tybee Lighthouse, 26, 33, 87.

Verelst, William, 23.

Walpole, Sir Robert, 11.
Walton, George, 64, 68, 72.
Waring, Dr. W. R., 119, 128.
Washington, George, 71, 83, 84, 85, 86, 87, 91, 95, 131.
Wayne, Gen. Anthony, 74.
Wayne, James M., 114.
Wesley, Rev. Charles, 25, 28.
Wesley, Rev. John, 25, 27, 28, 86.
Williams, Richard F., 129.
Williams, Thomas F., 129.
Williams, William T., 128.
Williamson, John P., 104.
Williamson, Mr. and Mrs., 28.
Whitefield, Rev. George, 28, 29, 32, 35, 41, 58, 59, 129.
Whitney, Eli, 91.
Wright, Gov. James, 51, 52, 56, 57, 58, 59, 63, 64, 65, 67, 68, 72, 74.

Yoakley, Captain, 20.

Zouberbuhler, Rev. Bartholomew, 51.
Zubly, Rev. John J., 50, 67.

Map of Savannah